Art and Autoradiography

Art and Autoradiography: Insights into the Genesis of Paintings by Rembrandt, Van Dyck, and Vermeer

The Metropolitan Museum of Art, New York

This volume has been made possible by Rowland Foundation, Inc.,
which supported the research, and by Lester Wolfe, who
provided a grant for the publication.

Published by The Metropolitan Museum of Art, New York
Bradford D. Kelleher, Publisher
John P. O'Neill, Editor in Chief
Rosanne Wasserman, Editor
Roberta Savage, Designer

Library of Congress Cataloging in Publication Data

Main entry under title:
Art and autoradiography.

 Research conducted jointly by the Metropolitan Museum of Art,
New York, and the Chemistry Department of Brookhaven National
Laboratory, Upton; Maryan Wynn Ainsworth, principal inves-
tigator.

 1. Painting—Autoradiography. 2. Rembrandt Harmenszoon
van Rijn, 1606–1669. 3. Dyck, Anthonie van, Sir, 1599–1641.
4. Vermeer, Johannes, 1632–1675. I. Ainsworth, Maryan Wynn.
II. Metropolitan Museum of Art (New York, N.Y.) III. Brookhaven
National Laboratory. Chemistry Dept.

ND1635.A77 751.6'2 81-18795
ISBN 0-87099-285-6 AACR2
ISBN 0-87099-286-4 (pbk.)

ON THE COVER/JACKET: Plate 45. Fifth autoradiograph of
Rembrandt Harmensz. van Rijn, *Self-Portrait,* 1660. The Metro-
politan Museum of Art, Bequest of Benjamin Altman, 1913
(14.40.618)

Contents

Preface 6

Acknowledgments 7

1. Paintings by Van Dyck, Vermeer, and Rembrandt
Reconsidered Through Autoradiography 9
 Maryan Wynn Ainsworth
 John Brealey
 Egbert Haverkamp-Begemann
 Pieter Meyers

2. Pigments and Other Painting Materials 101
 Pieter Meyers
 Maryan Wynn Ainsworth
 Karin Groen

3. The Technical Procedures and the Effects of
Radiation Exposure upon Paintings 105
 Pieter Meyers
 Maurice J. Cotter
 Lambertus van Zelst
 Edward V. Sayre

List of Paintings Studied 111

Preface

This study publishes for the first time the results of the investigation of old-master paintings by means of a new technique. This technique, neutron activation autoradiography, was first applied to nineteenth-century paintings in the 1960s and was recently extended to works of the seventeenth century. Autoradiography provides previously unobtainable information about the substructure of paintings and, thereby, about their genesis and condition. Among the other methods of providing images of the paint structure below the surface, X-ray radiography has been the most successful. Soon after their discovery by Roentgen in 1895, X rays were used to produce radiographs of paintings that presented images of at least part of the structure beneath the paintings' surfaces. Since that time X-ray radiography has been employed routinely in structural studies of paintings, providing invaluable information on painting techniques and helping to solve problems of attribution and authenticity. More recently, application of infrared reflectography has allowed a view of carbon black underdrawings on light backgrounds beneath the surfaces of Renaissance paintings.

Autoradiography now further expands our knowledge of the invisible substructure of paintings. A total of thirty-nine paintings by seventeenth-century Dutch and Flemish painters (mainly Rembrandt and his school) were studied by means of this technique. The results are set forth in this study, which consists of three parts. The first deals with the art-historical findings, while the second and third describe details of the technical side of the process.

MWA, 1982

Preface to the Second Printing

Since the publication of *Art and Autoradiography* in 1982, new studies using neutron activation autoradiography have been initiated, and further advances have been made on the technique itself. The Smithsonian Institution's Conservation Analytical Laboratory and National Museum of American Art are collaborating on two research projects, one on the paintings of Thomas Wilmer Dewing and the other on the works of Albert Pinkham Ryder. The use of the reactor at the National Bureau of Standards for these projects prompted a modification of that facility and further testing of materials (see the paper by M. Ligesa et al. in the Proceedings of the American Institute for Conservation Meeting, Vancouver, May, 1987). The preliminary report of this research supports the findings of our 1982 publication by indicating that the doses of radiation used in neutron activation autoradiography do not cause an observable increase in the oxidation of linseed oil.

Autoradiography has begun to play an increasingly important role in the visual scrutiny of paintings by Rembrandt, particularly in debates over connoisseurship issues. Results of the Metropolitan Museum's study have appeared in volume two of *A Corpus of Rembrandt Paintings* by J. Bruyn et al., The Hague, 1986, furthering our aim to make this material available to a wider audience of readers interested in the working methods of seventeenth-century artists.

Recently, researchers in West Berlin used autoradiography to clarify the particular handling of paint in a disputed work in the Gemäldegalerie, the *Man with the Golden Helmet* (see J. Kelch. Ed., *Bilder im Blickpunkt, Der Mann mit dem Goldhelm*, 1986). As was the case with our study, this research is being carried out by an interdisciplinary team from three institutions, the Gemäldegalerie, the Rathgen-Forschungslabor, and the Hahn-Meitner-Institut. Their original study has now grown into an ongoing investigation of all of the paintings in the Rembrandt group at the Gemäldegalerie, for which a new method of autoradiography by a cold

neutron guide has been developed (see C. O. Fischer et al., "Neutron Guide Autoradiography of Paintings at a Cold Neutron Guide," *Kern Technik*, in press).

We are particularly pleased about these developments, since the new studies will make use of the archive of autoradiographs at the Metropolitan Museum. The extraordinary value of information from autoradiography is reconfirmed by ongoing research. It is hoped that the reissue of this volume will encourage other collaborative ventures between institutions using this method.

MWA, 1987

Acknowledgments

The research was carried out jointly by The Metropolitan Museum of Art, New York, and the Chemistry Department of Brookhaven National Laboratory, Upton, under the guidance of an interdisciplinary committee consisting of Maryan Wynn Ainsworth and Egbert Haverkamp-Begemann (art historians), John Brealey (paintings conservator), and Pieter Meyers (physical scientist). As the principal investigator for the project, Ms. Ainsworth collated the material for and wrote the first draft of the art-historical findings. During various stages of the project, the committee was assisted by one art historian, John Walsh (formerly The Metropolitan Museum of Art, currently J. Paul Getty Museum, Malibu); physical scientists Maurice J. Cotter (Queens College of the City University of New York), Lambertus van Zelst (formerly The Metropolitan Museum of Art, currently Smithsonian Institution, Washington), and Edward V. Sayre (Brookhaven National Laboratory, Upton); and Karin Groen (Central Research Laboratory for Objects of Art and Science, Amsterdam), who prepared, examined, and interpreted most of the paint cross sections.

This investigation could not have been undertaken without the continued interest and generous financial support of Rowland Foundation, Inc., for the last three years. We are enormously grateful to this foundation and to Lester Wolfe, who provided a grant for the publication of our findings. The authors wish to thank Sir John Pope-Hennessy, Katharine Baetjer (Department of European Paintings, The Metropolitan Museum of Art), George Szabo (Robert Lehman Collection, The Metropolitan Museum of Art), and their staffs for making the paintings available; Joyce Plesters (National Gallery, London) for carrying out an extensive study on paint cross sections from Rembrandt's *Aristotle with a Bust of Homer*; and Ernst van de Wetering (Central Research Laboratory for Objects of Art and Science, Amsterdam) for sharing his extensive knowledge and understanding of Rembrandt's working methods. Furthermore, we are indebted to Gary Carriveau, Mark Leonard, and Herman Schroeder, who contributed to the dose rate measurements and the materials testing program; and to Elizabeth Burt and Lore L. Holmes, who assisted in the experimental part of the autoradiography project. Finally, for their assistance during procedures at Brookhaven National Laboratory, we are grateful to Tom Holmquist, Mike McKenna, Dave Rorer, and other staff members of the Medical Research Reactor; and to John Warren and Ira Still of the Instrumentation Department.

We wish to thank the Central Research Laboratory for Objects of Art and Science, Amsterdam, for generously allowing their staff members E. van de Wettering and K. Groen to contribute their expertise to our project. Parts of this research were performed at Brookhaven National Laboratory under contract with the United States Department of Energy supported by its Division of Basic Energy Sciences.

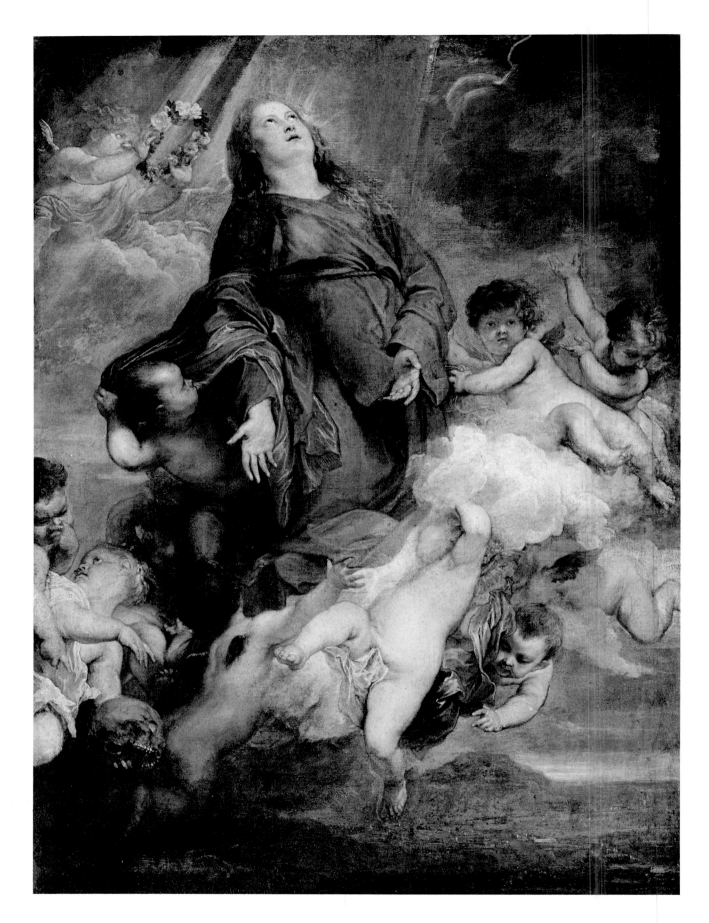

Plate 1. ANTHONY VAN DYCK, *Saint Rosalie Interceding for the Plague-stricken of Palermo,*
ca. 1624. Oil on canvas, 99.7 x 73.7 cm. (39¼ x 29 in.). The Metropolitan Museum
of Art, Purchase, 1871, 71.41

1

Paintings by Van Dyck, Vermeer, and Rembrandt Reconsidered Through Autoradiography

Maryan Wynn Ainsworth
John Brealey
Egbert Haverkamp-Begemann
Pieter Meyers

An artist's creative process and the evolution of a painting may be studied by various means: with the aid of occasional surviving documentation, through the artist's preparatory sketches, by close examination of the work for pentimenti and overlapping edges and forms, and by technical means such as X-ray radiography and infrared photography. Added to these is a new method of remarkable significance, neutron activation autoradiography.[1] First developed by Heather N. Lechtman and Edward V. Sayre,[2] autoradiography was subsequently employed in an investigation of nineteenth-century American paintings and, later, of various paintings at the Heckscher Museum, Huntington, N.Y.[3] Most recently (June 1976 to September 1980) a group of seventeenth-century Dutch and Flemish paintings from The Metropolitan Museum of Art was analyzed through this technique (see List of Paintings Studied).

Autoradiography is a nondestructive technique used here for the examination of underlying paint layers. With this method a mild transient radioactivity is generated by placing the painting in a beam of thermal neutrons for a short period of time. Immediately following the activation procedure, a series of photographic films is placed in contact with the surface of the painting. For each exposure standard-size films (of a type commonly used in X-ray radiography) are cut and pieced together to form the exact dimensions of the painting. Beta particles (electrons), emitted in the decay of the radioactive elements present in the painting, sensitize the film.

Upon development and fixing, the film will show the distribution (location and density) of those pigments and other painting materials that contain radioactive elements at the time of film exposure. This process is schematically shown in Figure 1. A series of such full-scale photographic images, called autoradiographs, consists of several consecutive exposures: the first ones are short exposures obtained only minutes after the neutron activation; later exposures are started hours, days, and even weeks after activation. Film exposure times vary accordingly from several minutes for the first autoradiograph to several weeks for the last one. Figure 2 presents a schedule of experiments that take place during the fifty-day period following activation in which nine autoradiographs are produced. Because of the differences in the decay times of the radioactive elements, different images are generally observed among the series of nine autoradiographs. This does not mean, however, that each of the nine autoradiographs is different; consecutively produced autoradiographs may show identical images. For this study a selection has been made of the most informative autoradiographs for each painting discussed.

At three different times in between autoradiographic exposures, gamma-ray energy spectra measurements are taken in order to identify which elements are present and to make quantitative estimates of the relative abundances of these elements in the painting. Such measurements also allow the calculation of electron emission rates for each of the elements detected. This in turn makes it possible to determine, for any given period after activation, which elements contribute to the blackening of the film and to estimate the extent of blackening attributed to each of these elements.

Table 1 shows a listing of the various pigments that were commonly used in seventeenth-century Dutch and Flemish paintings. This table also contains information on the chemical elements, with their associated painting materials, whose distribution can be observed in autoradiographs. However, not all elements

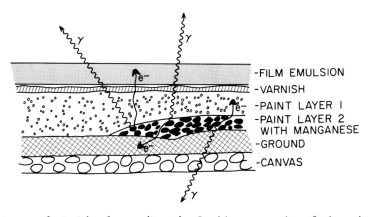

Figure 1. *Diagram of principles of autoradiography.* In this cross section of a hypothetical painting after neutron activation, only paint layer 2 contains radioactive elements (for example, manganese). The following events are shown: a) gamma rays (γ) emitted from layer 2 in the decay of radioactive manganese escape without interacting with film emulsion; b) electrons (e-) emitted from layer 2 in the decay of radioactive manganese do not reach film emulsion; c) electrons interact with film. After development and fixing, the film will be darkened only in the area directly above the paint layer that contains manganese. An important aspect of this technique is that the paint layer may be either far below or quite near the surface. Even though paint layer 2 is masked from view by paint layer 1, its image would be clearly visible on the film.

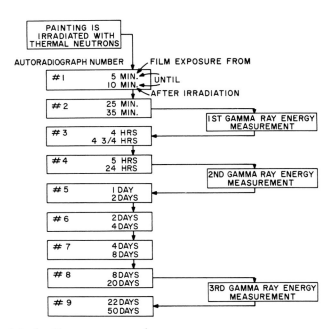

Figure 2. Schedule for film exposures and gamma-ray energy measurements

Chemical element	Associated pigment	Radioactive isotope formed during activation and its half-life	Time period after activation during which best images in autoradiographs are produced
manganese	umber, dark ocher	Mn56, 2.6 hours	0–24 hours
copper	malachite, azurite, verdigris	Cu66, 5.1 minutes Cu64, 12.8 hours	0–20 minutes 1–3 days
sodium	glue, medium, canvas, ultramarine	Na24, 15.0 hours	1–3 days
arsenic	smalt, glass	As76, 26.5 hours	2–8 days
phosphorus	bone black	P^{32}, 14.3 days	8–30 days
mercury	vermilion	Hg203, 48 days	more than 25 days
cobalt	smalt, glass	Co60, 5.3 years	more than 25 days

Table 1. Chemical elements and associated pigments most frequently observed in autoradiography of seventeenth-century Dutch and Flemish paintings.
The following pigments generally do not cause distinct images in autoradiographs: chalk, lead white, ocher, lead-tin yellow, lakes, madders, and indigo.

present in a painting form radioactive products suitable for autoradiography. Examples in this category are lead and iron, even though they are among the most abundant in paintings (i.e., lead in lead white and iron in ochers and umbers). The distribution of lead white, however, can be accurately observed in X-ray radiography, a technique that in this respect conveniently complements autoradiography. Since carbon, hydrogen, and oxygen are also among those elements that do not form radioactive elements useful in autoradiography, this technique will generally not yield information about the presence and distribution of organic pigments.[4]

The pigments or pigment mixtures in the paint applications of images seen in autoradiographs can be identified in nearly all cases. The autoradiographs, however, do not provide information about the depth below the surface at which these paint applications occur. For that purpose microscopic examination of paint cross sections can be employed to locate a specific paint application (see Chapter 2).

As the distribution of pigments on a canvas results from the process of painting, autoradiography may recapture unique evidence of working methods: from the application of the ground layers, to the underpainted sketch, to blocking out, and, finally, to the addition of multiple paint layers in the working up of the image. The character of brushstrokes is part of the identification or "handwriting" of an artist that may be studied more comprehensively through this method. In addition, brushwork that has become illegible in paint layers considerably darkened over time is once more apparent. This makes it possible to recover areas of subtle tonal transitions as in the backgrounds of Rembrandt paintings and details that appear on the surface of the painting as confusing remnants. Pentimenti, too, may be more clearly deciphered for their contribution to the understanding of an artist's style and sometimes of the iconography of the painting.

With this improved reading of multiple layers and stages of painting, the interrelationship of works of art in different mediums becomes more obvious. In

Van Dyck, for example, an underpainted sketch for a self-portrait assumes a form similar to the artist's etchings for his *Iconographie,* a print series of the 1630s. In Rembrandt, the preliminary sketches discovered in the autoradiographs reveal similarities to the artist's contemporary pen-and-wash drawings. The manner in which Rembrandt used stippling and long, disengaged strokes for tonal variations in the background areas of certain paintings is also found in some of his etchings. Even the method of building up a painting from a sketch to the final layer is paralleled in Rembrandt's printmaking.

Because autoradiography can distinguish fine details of paint application, it is useful in questions of attribution and authenticity. In some cases, a painting of a later century may be recovered under a purportedly earlier one, or a "period" work may be found totally lacking in conventional structure.[5] These are obvious examples of deceit. To distinguish the efforts of a master from those of his pupils or followers, however, necessitates the scrutiny of multiple autograph works. In the case of Rembrandt, autoradiography has added information to weight an argument one way or another regarding attributions that fall in the 1630s and late 1650s to 1660s.

Finally, this technique is helpful to the conservator in cases where X-ray radiography is of virtually no use. X-ray radiography shows almost exclusively lead-based pigments (especially lead white). Because these pigments are remarkably durable, an X-ray radiograph seldom will yield a great deal of information about a painting's condition. Much of the damage usually occurs in the browns and blacks, which are not visible in the X-ray radiograph. These pigments by nature are fugitive. In addition, some become darker with age (e.g., umbers) or fade to a gray tone with exposure to light (e.g., Van Dyck brown). As many of these pigments are recorded by autoradiography, it is now possible to discern the exact extent of losses in areas that are largely overpainted. Restorations can never simulate convincingly either the brushwork or the pigment composition of the original paint, and therefore are conspicuous features in autoradiographs.

Anthony van Dyck:
Saint Rosalie Interceding for the Plague-stricken of Palermo

Of all the works studied through autoradiography in our project, *Saint Rosalie Interceding for the Plague-stricken of Palermo* (Plate 1) shows most fully the potential of the technique. The Metropolitan Museum's work is one of several representations of this subject painted by Van Dyck during his Italian sojourn (1621–27).[6] Among the many extant versions are two nearly identical to the Museum's picture, one in the Bayerische Staatsgemäldesammlungen, Munich, and one in the Museo del Prado, Madrid.[7] By recovering visual documentation of Van Dyck's painting procedure, autoradiography adds arguments in favor of the priority of the New York painting over other versions.

In the third autoradiograph (Plate 3) the even, overall darkening of the films is due to the distribution of radioactive manganese in the umber of the ground layers (see Colorplate G). Also clearly visible and again due to the presence of umber is the underpainted sketch for the *Saint Rosalie* design.[8] Horst Vey observed that there are no surviving oil sketches from Van Dyck's Italian sojourn.[9] There remain, as well, very few compositional drawings for paintings that were produced during that period.[10] This leads to conjecture about Van Dyck's use of a preliminary sketch in the underlying paint layers; autoradiography now seems to confirm the hypothesis.

The summary indications of forms, alteration of contours (the angel's head

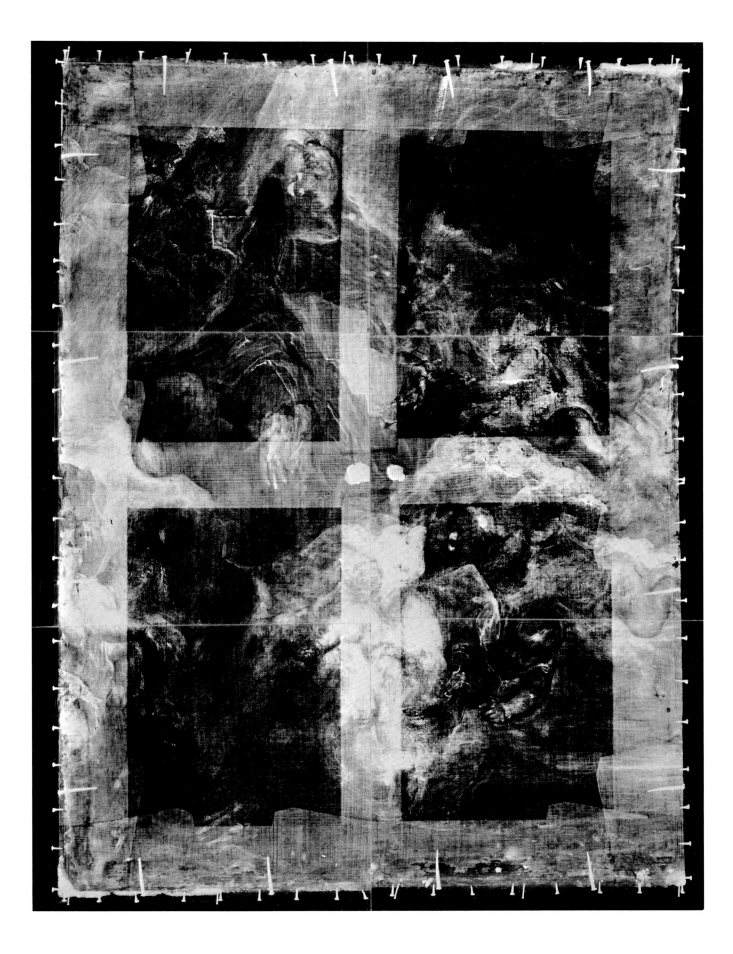

Plate 2. X-ray radiograph, *Saint Rosalie*

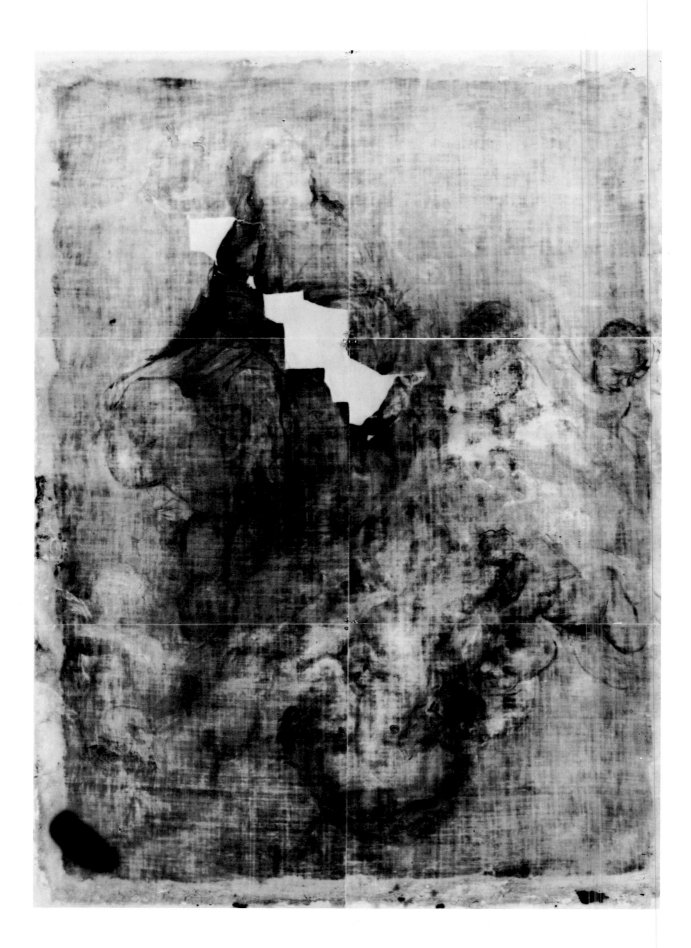

Plate 3. Third autoradiograph, *Saint Rosalie*

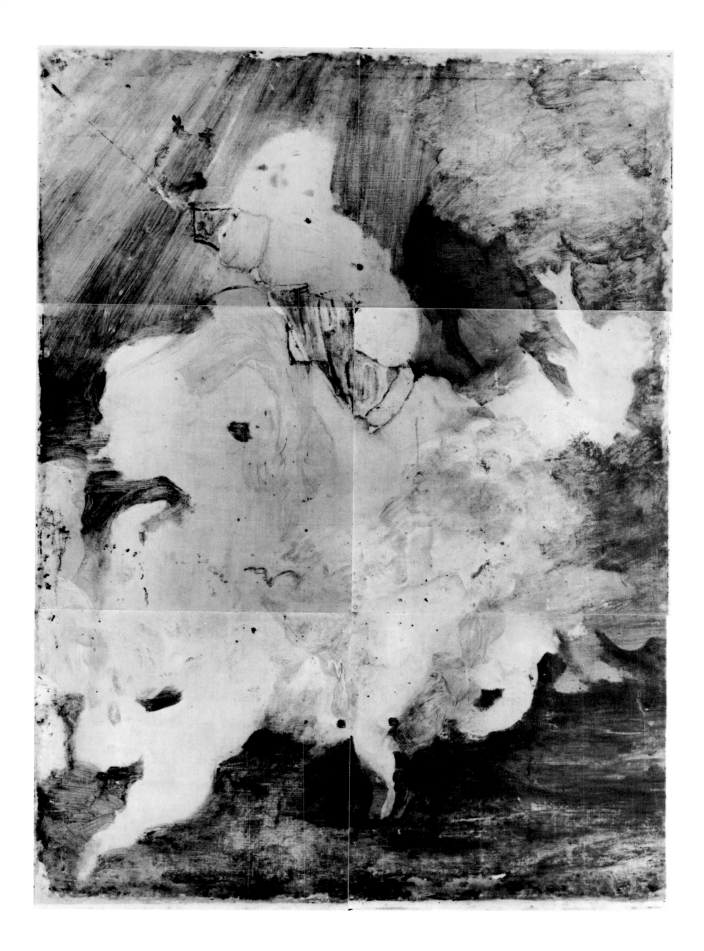

Plate 4. Sixth autoradiograph, *Saint Rosalie*

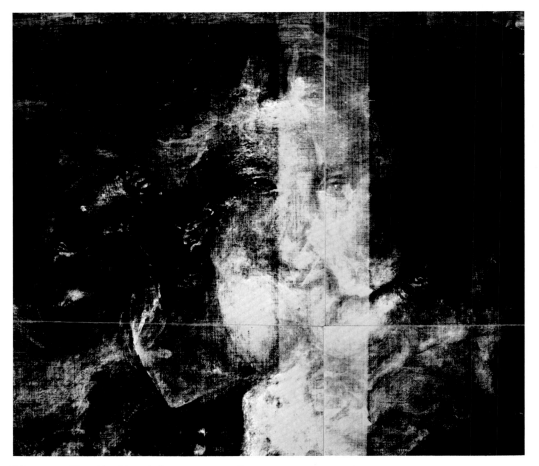

Plate 2a. Detail of head from X-ray radiograph, *Saint Rosalie*

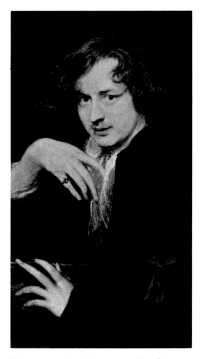

Figure 3. Anthony van Dyck, *Self-Portrait,* ca. 1622. Oil on canvas, 119.7 x 87.9 cm. (47⅛ x 34⅝ in.). The Metropolitan Museum of Art, The Jules Bache Collection, 1949, 49.7.25

at the far right), and freedom of the sketch (not all of which was followed in the upper paint layers)[11] show an evolving design. Conspicuously absent from Van Dyck's preliminary idea for the composition is the angel who crowns Saint Rosalie in the upper left corner of the completed picture. Because the cult of Saint Rosalie was founded only when she became the patron of the plague victims of Palermo in 1624, it fell to Van Dyck to establish a suitable iconography.[12] The addition of the angel with a wreath of roses (denoting heavenly blessing and the name of the saint)[13] may indicate progressive stages in the development of a specific iconography.

Van Dyck's traditional technique[14] is exemplified further in the sixth autoradiograph of the series (Plate 4). After the ground application and preliminary sketch (Plate 3), the artist proceeded to a stage in which he freely filled in the background, varying his strokes for rays of light, clouds, and landscape features.[15] The energetic and direct approach of the artist is well demonstrated in the clarity of these discrete areas of brushwork. Van Dyck left the figural group in reserve and freely worked around and occasionally over portions of the preliminary design (e.g., the forehead of Saint Rosalie). Here and there, perhaps, he considered the alteration of certain details (e.g., repositioning the lower central angel's left leg; painting out the angel to the lower right and portions of the bodies of the two upper right angels). Within the reserved area a confusion of shapes represents superimposed layers of the final building up of the painting. Only comparative autoradiography of the Munich and Madrid paintings could add further evidence toward establishing the New York work as a prototype. However, the numerous alterations in design at every stage of painting (i.e., in the underpainted sketch,

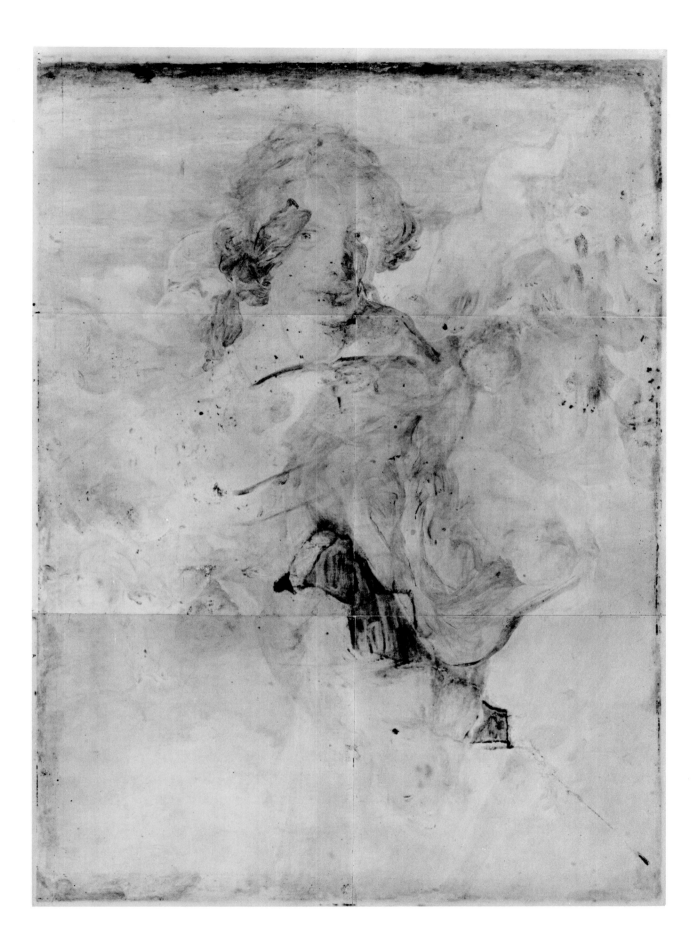

Plate 5. Eighth autoradiograph, *Saint Rosalie*

in blocking out, and in the final layers) indicate an evolving creative process rather than the fixed design of a replica.[16]

This painting by Van Dyck is a good example of the occasional startling revelation offered by autoradiography. Through X-ray radiography the exact details of a head appearing upside down in the lower portion of the canvas (Plates 2, 2a) cannot be clearly discerned. The eighth autoradiograph (Plate 5) unmasks the sitter's identity. It is a painted sketch of the young Van Dyck, whose characteristic features (large eyes; long, prominent nose; full, sensitive lips) are clearly recognizable from several contemporary self-portraits (see Figure 3).[17] As in some of his drawings for and first states of the *Iconographie,* Van Dyck limited his rendering to the head and a very summary indication of the body (collar and shoulder line only). The recovery of this portrait, so ingenuous in the manner in which it addresses the viewer, is due to Van Dyck's choice of materials. This preliminary sketch is mainly in bone black, while that for *Saint Rosalie* is mostly in umbers.[18] As a result of the elemental composition of these pigments, the two images appear in autoradiographs produced at different times after activation. The recovery of either sketch is only possible through this method.

Finally, autoradiography reveals information about the physical state of the painting. A substantial canvas loss appears in the center of Plate 3 as a blank, jagged form and in Plates 4 and 5 as a repair. Original canvas also torn out but reattached in this region can be identified at Saint Rosalie's right shoulder and at the lower right end of the loss as it conforms in appearance to the adjacent, intact areas. Further restorations are immediately recognizable in the autoradiographs as small dark dots (e.g., at the edges of Plate 4).

Johannes Vermeer:
A Girl Asleep

An underpainted sketch as we have seen in the Van Dyck painting and will see in Rembrandt is not apparent in the Vermeer paintings studied thus far. If we may understand Vermeer's *Art of Painting* (Kunsthistorisches Museum, Vienna) not solely as an allegory but also as an accurate description of painting procedure, then we could expect an underdrawing in chalk for *A Girl Asleep* (Plate 6). Unfortunately, as autoradiography does not show chalk, this point cannot be proven. What is possible is to gain information about Vermeer's working method in the upper levels of the painting. The artist clearly reworked the painting several times to reach satisfactory solutions about both spatial relationships and iconography.

Hubert von Sonnenburg and Madlyn Millner Kahr have already noted several pentimenti in the X-ray radiograph (Plate 7), Von Sonnenburg pointing out a dog in the doorway and what he calls the decreased size of the picture frame at the upper left, and Kahr noting the head with two hat shapes and the shoulders of a man in the place of the background mirror and table (Plates 7, 7a).[19] To these should be added the plate on the table at the left hand of the sleeping girl and evidence of some changes in the far right of the painting. In addition to what we already knew, autoradiography clarifies some of these shapes and adds to them the increased (not decreased) size of the painting at the upper left (Plate 9), a chair or table at the middle right edge (Plate 8), a design change in the forefront chair (Plate 9), and, perhaps most important, some exquisitely drawn grapes and grape leaves beneath the present still life (Plates 10, 10a; Colorplate C).

Clearly some of these pentimenti concern alterations in the spatial structure of the painting. When the dog was removed, it was partly replaced by the high-backed chair in the lower right corner, which served to lead the spectator's eye to

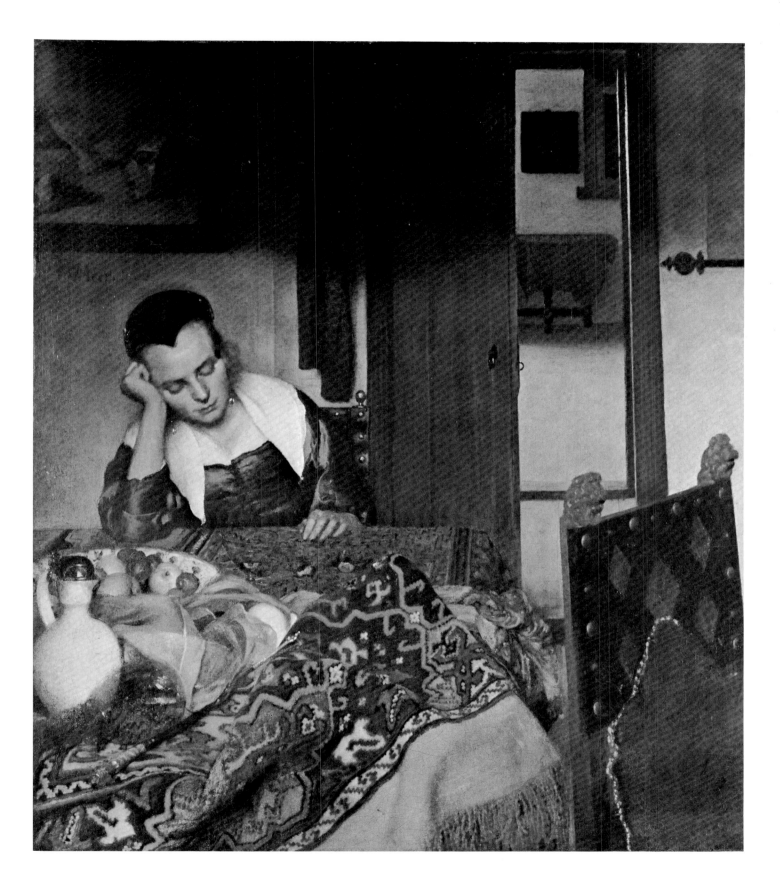

Plate 6. JOHANNES VERMEER, *A Girl Asleep*, signed I·VMeer, ca. 1657. Oil on
canvas, 87.6 x 76.5 cm. (34½ x 30⅛ in.). The Metropolitan Museum of Art, Bequest
of Benjamin Altman, 1913, 14.40.611

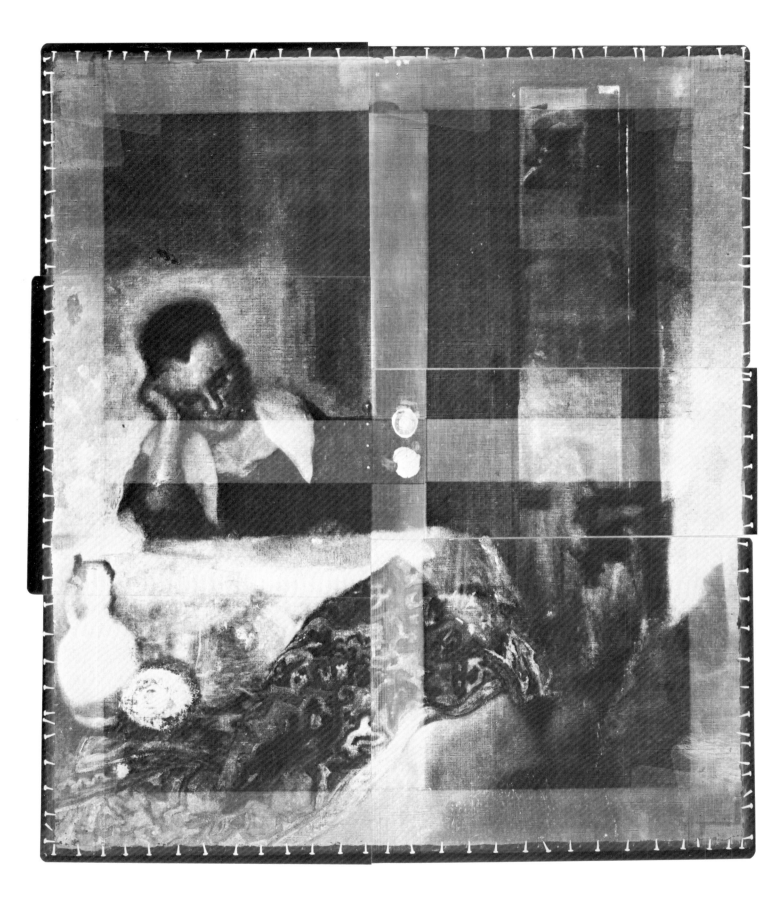

Plate 7. X-ray radiograph, *A Girl Asleep*

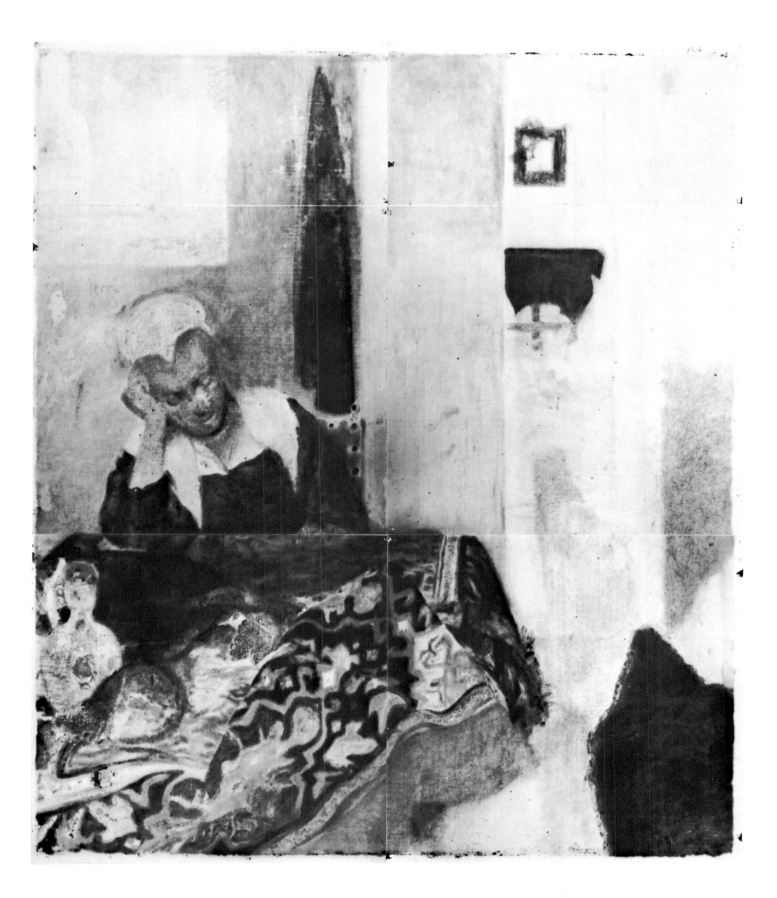

Plate 8. Sixth autoradiograph, *A Girl Asleep*

Plate 7a. Detail of man's hats from X-ray radiograph, *A Girl Asleep*

Plate 8a. Detail of man entering room from sixth autoradiograph, *A Girl Asleep*

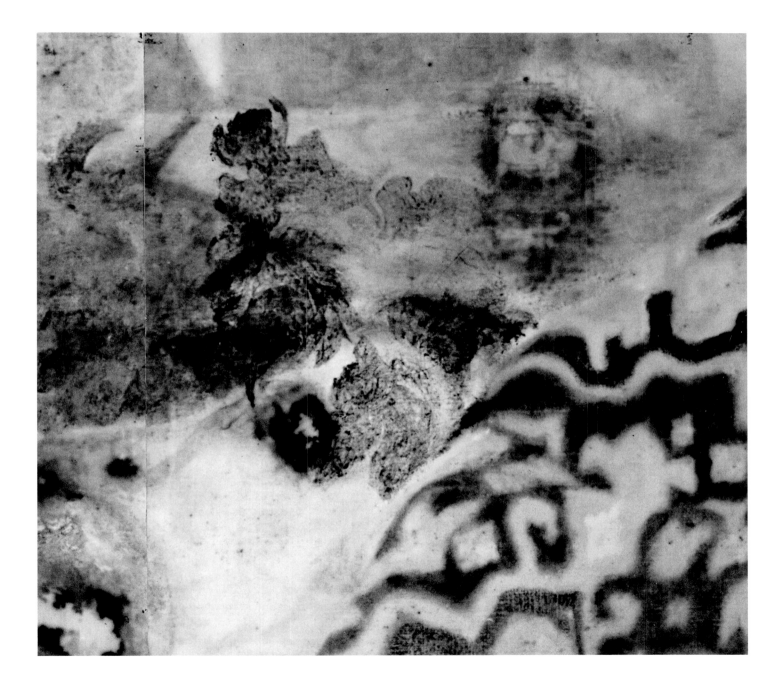

Plate 10a. Detail of grapes from fourth autoradiograph, *A Girl Asleep*

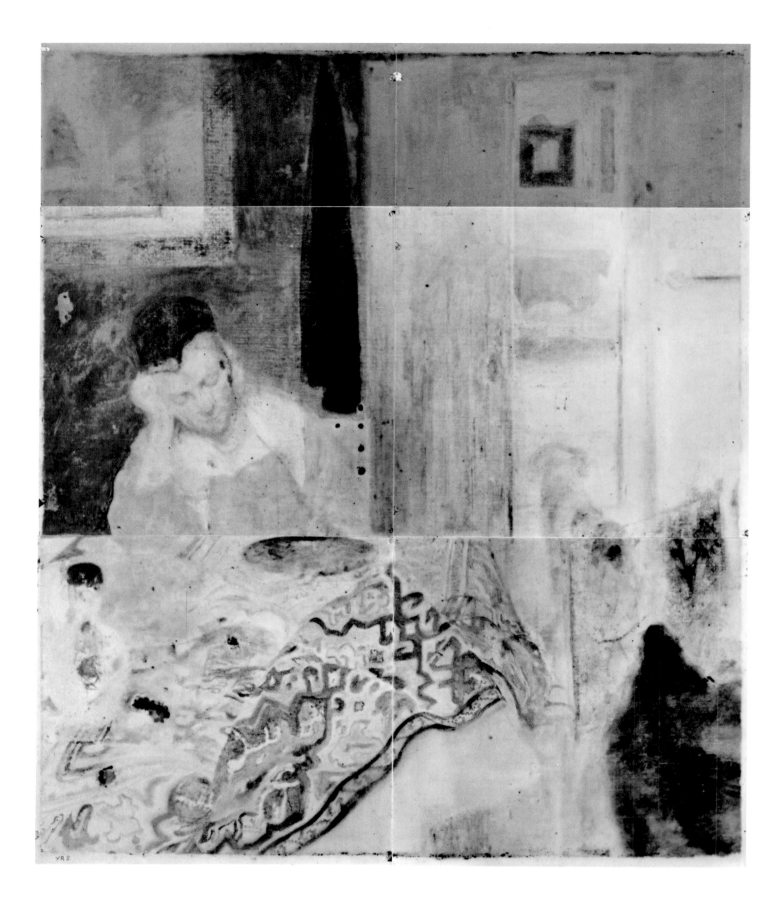

Plate 9. Eighth autoradiograph, *A Girl Asleep*

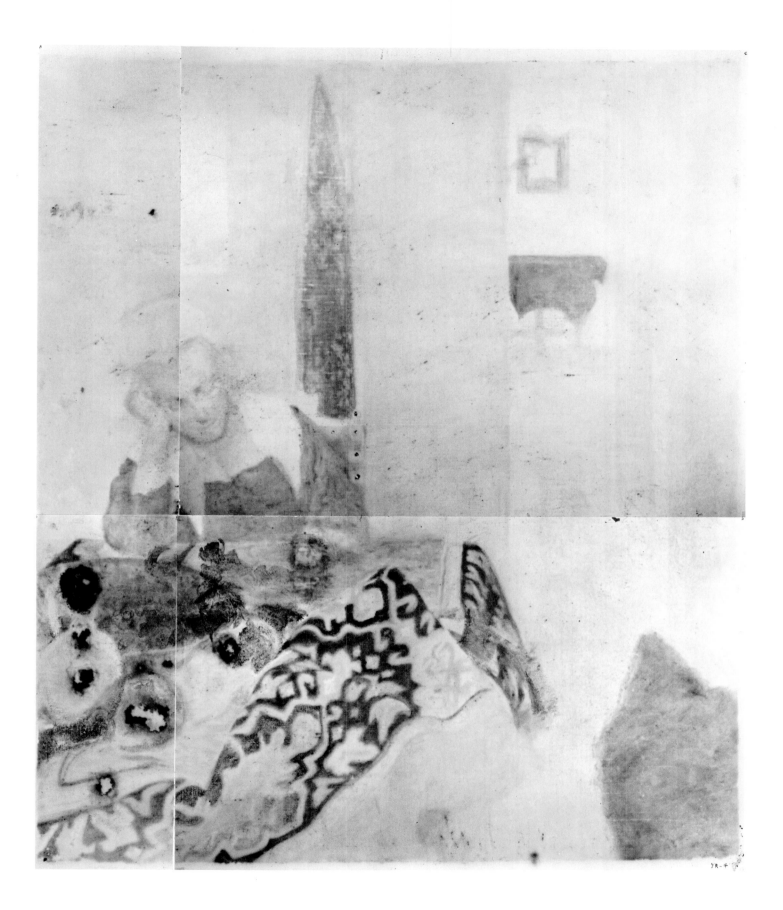

Plate 10. Fourth autoradiograph, *A Girl Asleep*

the background. Perhaps simultaneously an image at the far right, possibly a chair or table with cloth draped over it (Plate 8), disappeared from the composition. Vermeer partially scraped away this object and the dog[20] in reworking this area, replacing them with the chair, initially decorated with a brocaded design but later with diamond shapes.

Other pentimenti have to do more specifically with Vermeer's revised ideas for the subject of the painting. Though we cannot follow the artist's thought processes exactly, cross-section analysis has helped to clarify which compositional features appeared simultaneously. In approximately the same paint layer are the following: a smaller painting at the upper left; an empty plate on the table; the dog in the doorway (Plate 9); a man entering the room (Plate 8a); grapes and grape leaves in the bowl on the table (Plate 10).[21]

The many interpretations of the enigmatic subject matter of this painting[22] all involve common themes in seventeenth-century Dutch allegories—love, self-indulgence, sleep. Though we may not be able to pinpoint exactly Vermeer's original intentions, a case may be made for implied amorous meaning in the first design by the presence of the dog and male visitor and, perhaps, the precarious virtue of the maiden signaled by the bunch of grapes.[23] At one point Vermeer discarded the more explicit iconographical elements in favor of a concealed and more subtle allusion by enlarging the painting in the upper left corner. In reference to contemporary moral emblems, this picture represents Love (Cupid) casting down his mask in disparagement of the hypocrisy of love or in contempt for deceit or duplicity in love.[24]

These changes, revealed by a study of autoradiography and X-ray radiography together, constitute a major shift in representation from explicit to more implicit meaning. What amount of time intervened is impossible to say.[25] Certain clues, however, may be given by the evidence of the altered signature found in the sixth autoradiograph (Plate 8). The original signature, *I M Meer.*, corresponds to one found on Vermeer's *Diana and Her Companions* (Mauritshuis, The Hague), a painting of about 1654–56.[26] That which can be seen on the painting now, *I·Meer.*, is similar to those of later works, such as *A Street in Delft* of 1661 (Rijksmuseum, Amsterdam). It is possible that after substantially reworking the painting, Vermeer signed it again in somewhat altered form. However, this cannot be proven. Microscopic examination, in fact, shows that the *I* and the *V* were retouched later. Whether this constitutes simply a strengthening of letters already there but clearly fading, as are the *eer,* or tampering with the signature by someone who knew Vermeer's later paintings, remains unclear.[27]

Rembrandt
Harmensz. van Rijn

The artistic stature of Rembrandt has prompted numerous studies of his technique but seldom any concurrence on his working procedure.[28] More recently, technical examinations have become routine in studies of Rembrandt's oeuvre. These technical findings, however, are inevitably open to various interpretations, and the answer in many cases remains elusive. Because Rembrandt was a prolific artist who often applied new painting techniques, it is difficult to establish the norm for a given artistic phase.

Though autoradiography by itself cannot be touted as the final word, it can add significantly to the current information on Rembrandt's working method. The most notable findings of an autoradiographic study of thirty-four paintings

on canvas by and attributed to Rembrandt and his workshop are reviewed here. These works fall mostly in the periods of the 1630s and the late 1650s–60s.

Autoradiography contributes various details about each painting. Some general observations, however, may be made about painting technique in all the works studied. The ground layer preparation is identifiable in those autoradiographs where the canvas weave is visible. Works of the 1630s show this preparation in the first three or four autoradiographs of the series of nine, demonstrating the expected presence of manganese in the umbers of the first ground layer. This group of autoradiographs must be read in conjunction with the corresponding X-ray radiograph in order to distinguish the contribution of lead white to the grayish tone of the second ground layer or *imprimatura*. Autoradiographs of a number of the later paintings studied continue to show the canvas weave in the fifth and sixth films of the series, perhaps indicating a greater proportion of sodium in the glue sizing of the canvas. In other words, it is now possible to obtain some information about the ground layers visually from the autoradiographs. Some examples may show the specific method of application with a brush (indistinct edges) or palette knife (sharply defined edges).[29]

There have been many theories about Rembrandt's procedure subsequent to the application of ground preparation. The long-popular notion of Max Doerner, that Rembrandt worked on a preparatory painting of gray tones that established composition as well as lighting, is generally rejected.[30] Johannes Hell's theory, that Rembrandt's first design was laid in with lines drawn with the brush and application of tone over large areas with brown paint of greater or lesser transparency, was supported by observations made during the cleaning of the *Night Watch* (Rijksmuseum, Amsterdam).[31] The use of brownish paint in the monochrome underpainting has now become visible in areas of damage or where Rembrandt left it deliberately uncovered.[32]

Ernst van de Wetering and others have posited that the paucity of extant compositional drawings for paintings suggests the possibility of a sketch made directly on the canvas.[33] Autoradiographs provide the proof. The underpainted sketch varies in its complexity but, in our experience, little in its material. In nearly every case, the pigment used for the underpainted sketch was bone black.[34] Our investigation has also revealed that the sketch, though usually found in the layer above the ground, may also occur in upper layers, especially where the design has been altered. Clearly, for Rembrandt sketching was an integral part of the creative process.

Autoradiography confirms the findings of the *Night Watch* investigation: Rembrandt basically worked from back to front beginning with the background and leaving in reserve the foreground forms.[35] This was previously established by careful examination of overlapping paint layers of contours and by cross-section analysis. As Van de Wetering has pointed out, this slight overlapping of edges is part of the painting procedure and ought not to be confused with changes of mind or pentimenti.[36]

The pigments of the backgrounds in many Rembrandt paintings have considerably darkened and receded over time, so that the original intent of the artist is lost. Through autoradiography, the brushwork in these areas is more visible, and it is now possible to recapture some of the richness of originally existing tonal variations. In the earlier paintings (1630s) Rembrandt created these effects by a masterful arrangement of parallel and multidirectional strokes. Later, in the 1650s and 1660s, Rembrandt's increased interest in the texture of paint can be

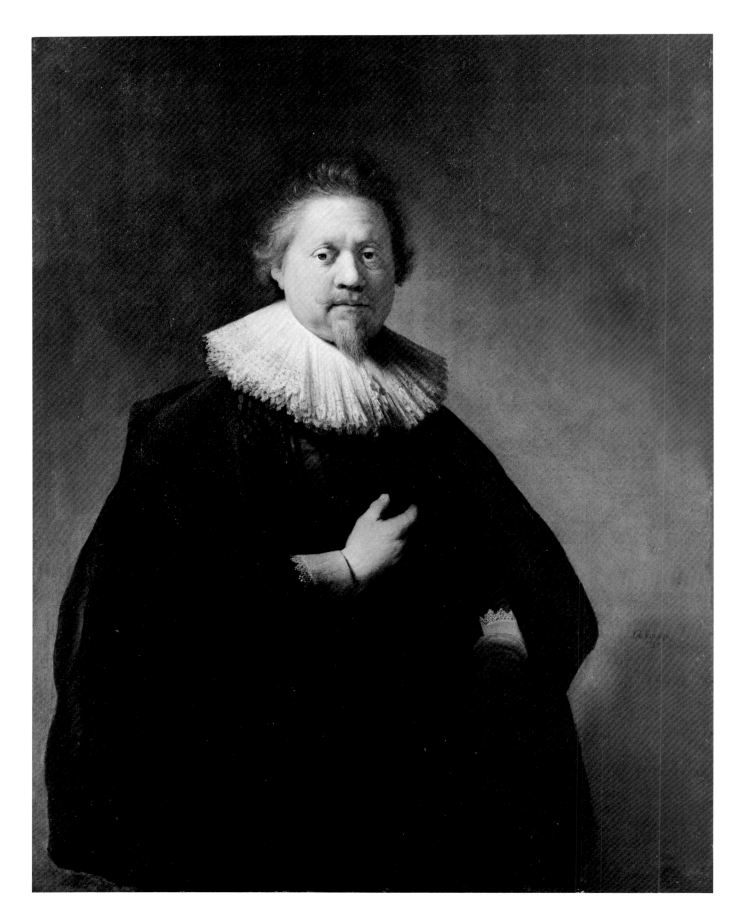

Plate 11. REMBRANDT HARMENSZ. VAN RIJN, *Portrait of a Man,* signed and dated
1632. Oil on canvas, 111.8 x 88.9 cm. (44 x 35 in.). The Metropolitan Museum of
Art, Bequest of Mrs. H. O. Havemeyer, 1929, H. O. Havemeyer Collection, 29.100.3

seen in the backgrounds where he scratched into and scraped away portions of the paint and superimposed stippling and longer, engaged strokes. The evidence, now revealed by autoradiography, shows a closer parallelism between the artist's working procedures in printmaking and painting than has been supposed previously.

Rembrandt's methods of working up the paintings varied. The evidence here shows some relatively straightforward and clear stages as well as much reworking and even resketching for new forms. The earlier paintings studied reveal a more traditional or systematic approach; the later works show substantial reworking at various stages.

Portraits of the 1630s and *Man in Oriental Costume*

Recently scholars have noted apparent differences in Rembrandt's handling of male and female portraiture, particularly in regard to surface quality and modeling.[37] In the case of the Metropolitan Museum's so-called Beresteijn pendants of 1632, *Portrait of a Man* and *Portrait of a Lady* (Plates 11, 15), this observation has led some (Gerson and Von Sonnenburg) to accept only the male portrait as Rembrandt's and to attribute the female portrait to his workshop.[38] However, close examination of the brushwork and working procedure of these paintings reveals Rembrandt's characteristic technique in both (compare Plates 13, 17). In general, the Beresteijn pair as well as the *Portrait of a Lady with a Fan* (Plate 19) show a consistently linear approach. In the autoradiographs, this approach is found not only in the distinct undulating contours of costume, but even in the features of the face, which were outlined with vermilion strokes (Plates 13, 17, 22).

Differences in Rembrandt's approach to male and female portraits do exist. In these examples, the number of pentimenti evident in the female portraits is not paralleled in the male portrait, suggesting some degree of indecision about the formal aspects of the former. In the Beresteijn man there is only one slight change in the otherwise firmly established design, the contour of his left sleeve (compare Plates 13, 14). In the pendant, there are changes in the position of both hands and the addition of the side table (compare Plates 17, 18). Similar alterations in the 1633 *Lady with a Fan* (Plates 19, 21, 22)—the exchange of the left-hand chair rest for a table, the contours of the hand and cuff at the right, and the removal of the center bow on the collar—also indicate some reworking toward a more satisfactory design.

In the *Lady with a Fan,* autoradiography clarifies the brushwork of the dress. The broad handling and voluminous structure of the skirt directly correspond to that found in Rembrandt's 1635 study in pen and ink with wash for *The Great Jewish Bride* (Figure 4), and especially in the black-chalk drawing *Saskia Seated in an Armchair* of about 1633 (Figure 5). In addition, there is some information about forms in the design that are now lost for the most part. Behind the sitter's left shoulder is part of the back of the chair (Plate 22), an elusive shape in the painting. Though there is little left of the severely abraded fan, autoradiography defines the original shape more clearly (Plate 22) and also demonstrates that the entire right hand was painted first before the darker tones of the fan's shadow were added (Plate 21). In both the female portraits (Plates 15, 19) the energetic working up of the background in parallel hatching and strengthening of the undulating contours of the figure with long brushstrokes are recovered in those areas where colors have darkened and receded over time, obscuring the original richness of the portraits.

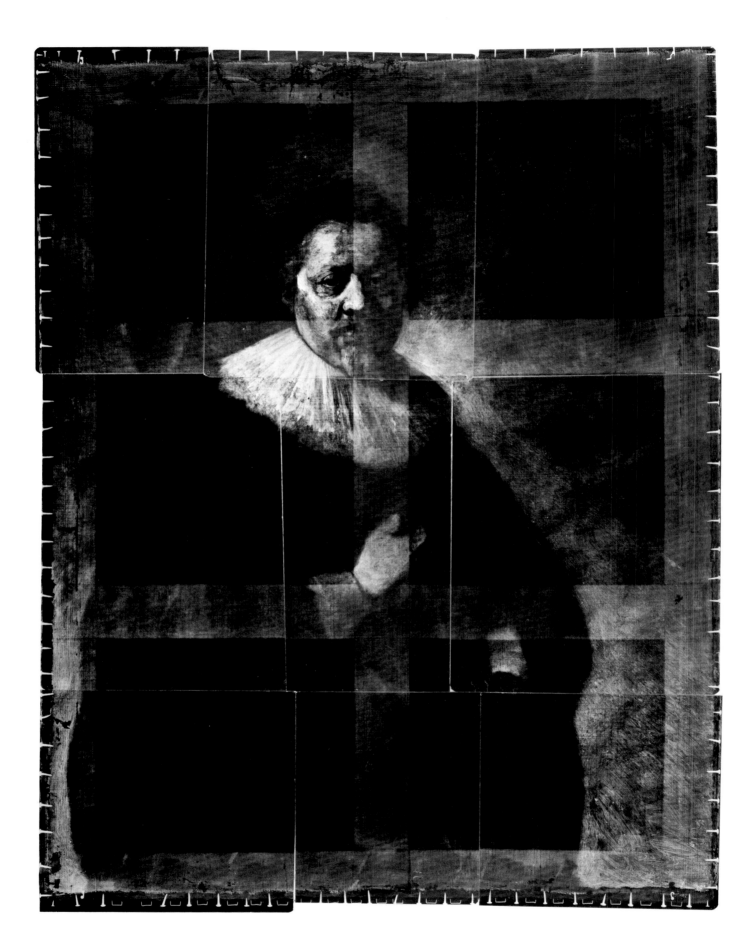

Plate 12. X-ray radiograph, *Portrait of a Man*

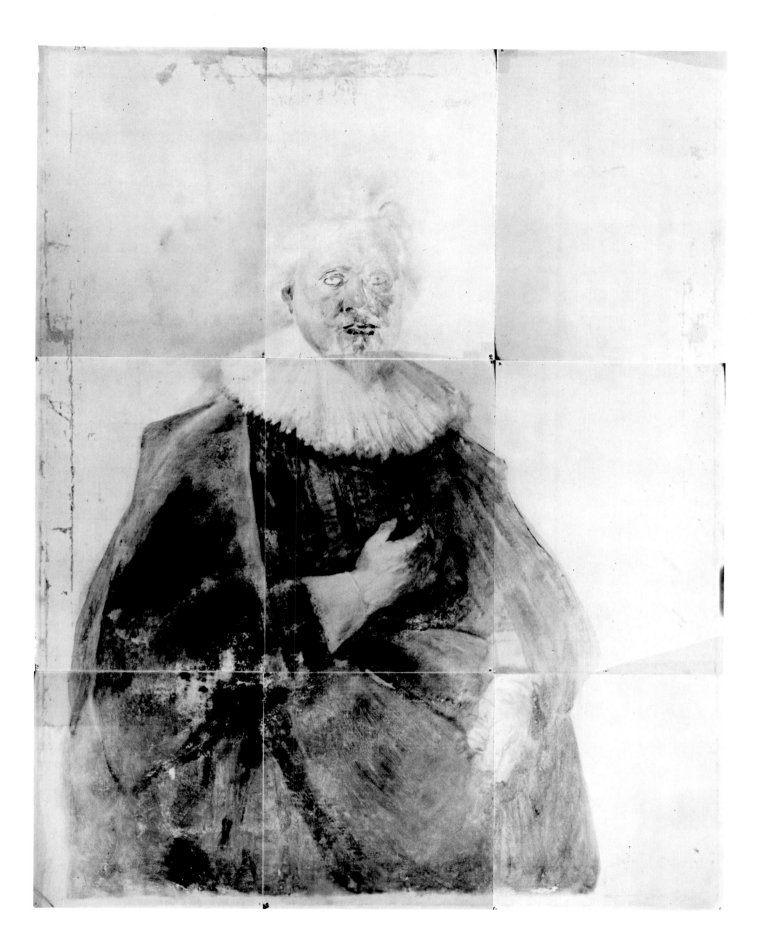

Plate 13. Ninth autoradiograph, *Portrait of a Man*

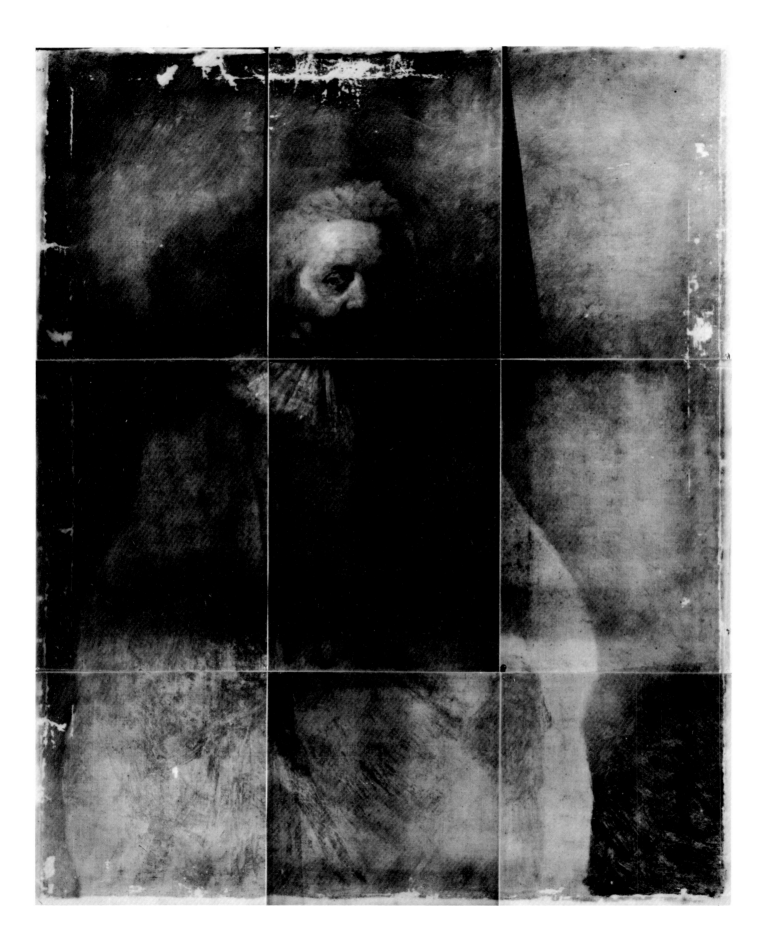

Plate 14. Third autoradiograph, *Portrait of a Man*

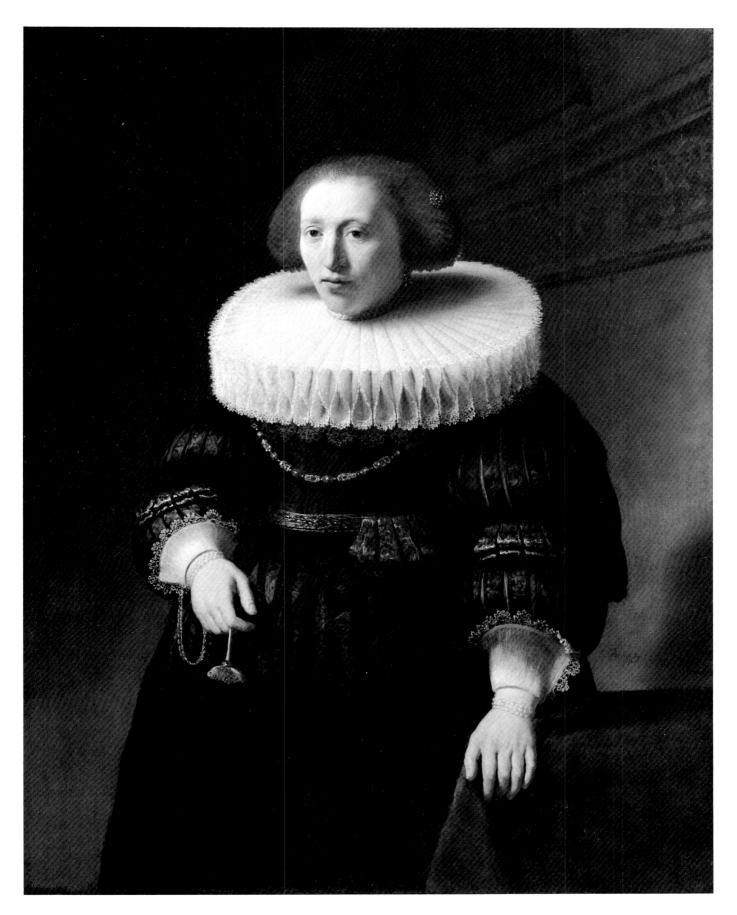

Plate 15. REMBRANDT HARMENSZ. VAN RIJN, *Portrait of a Lady*, signed and dated 1632. Oil on canvas, 111.8 x 88.9 cm. (44 x 35 in.). The Metropolitan Museum of Art, Bequest of Mrs. H. O. Havemeyer, 1929, H. O. Havemeyer Collection, 29.100.4

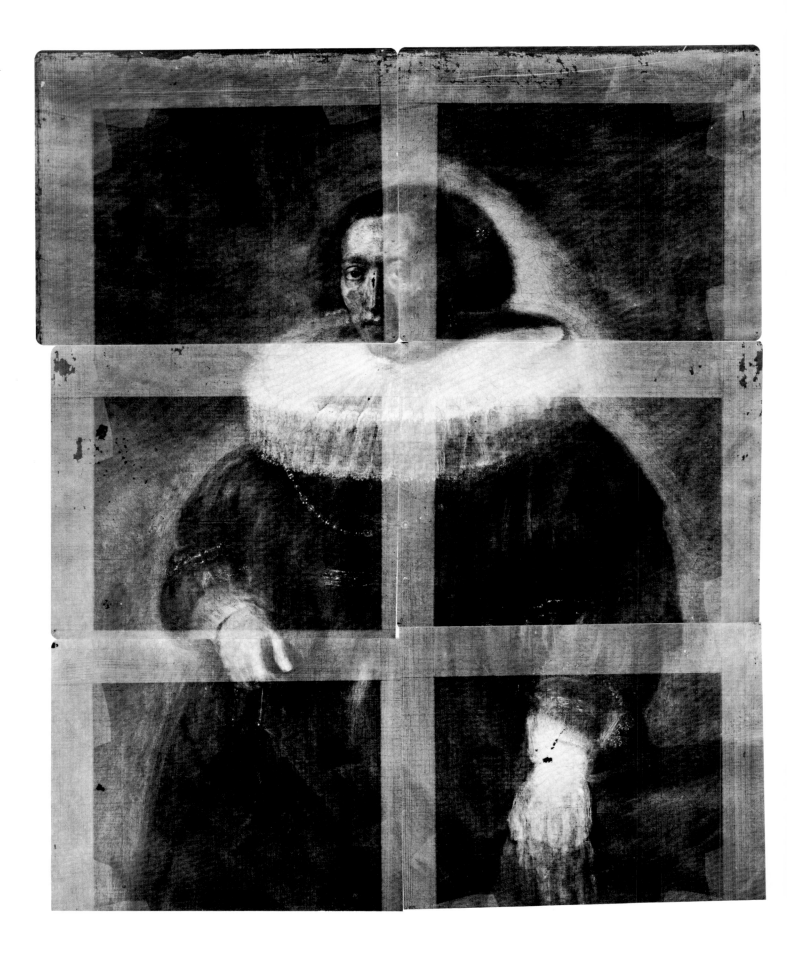

Plate 16. X-ray radiograph, *Portrait of a Lady*

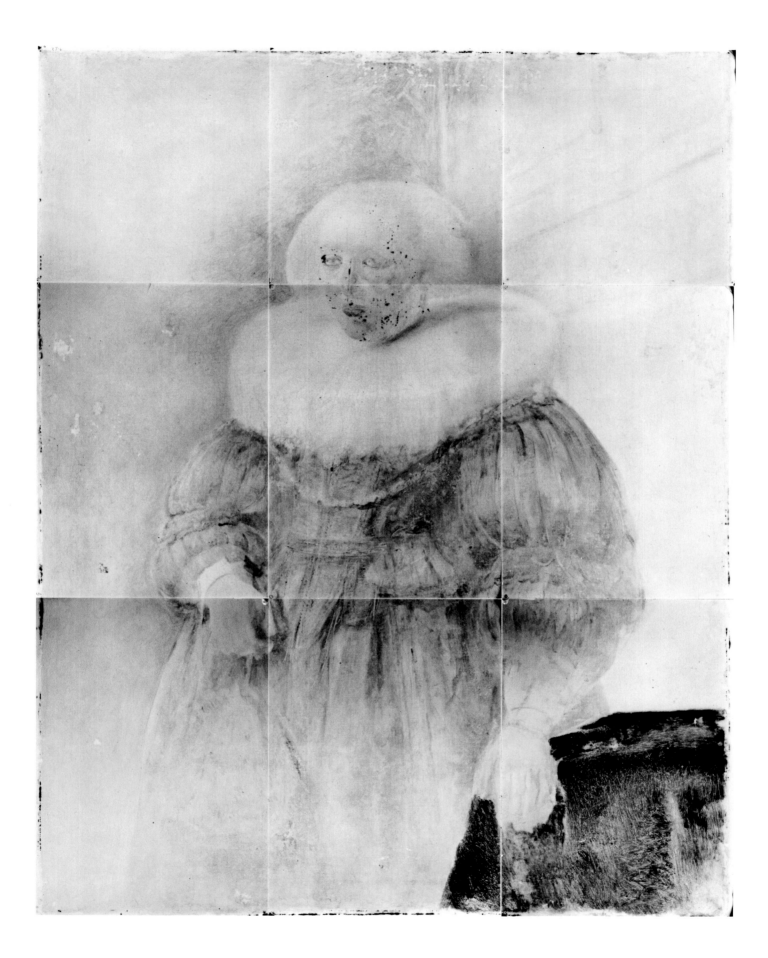

Plate 17. Sixth autoradiograph, *Portrait of a Lady*

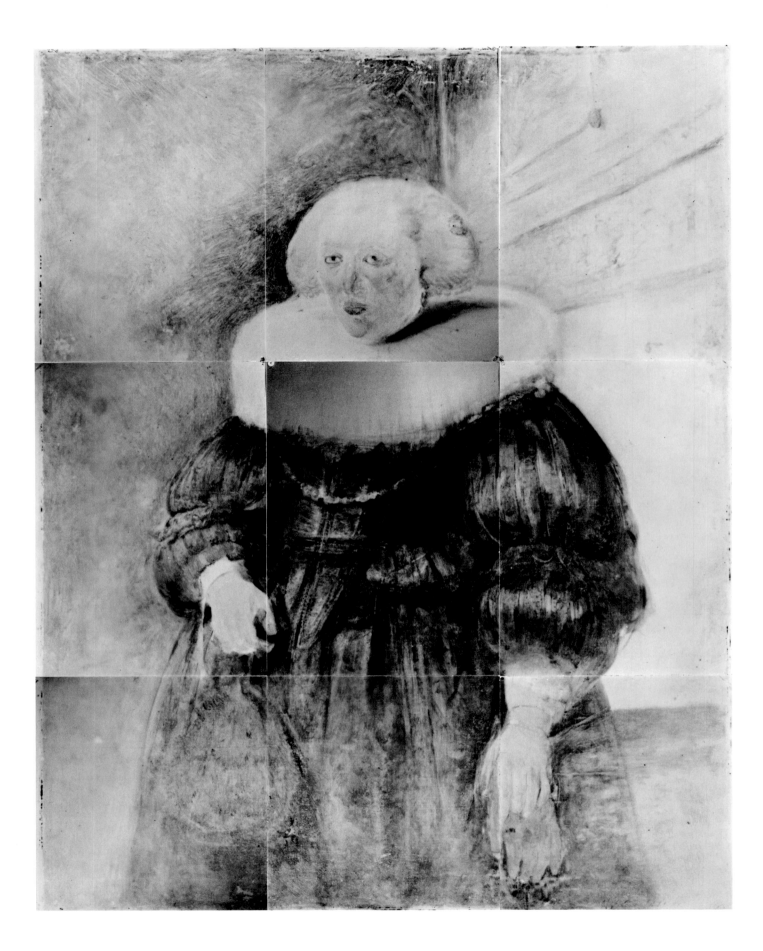

Plate 18. Eighth autoradiograph, *Portrait of a Lady*

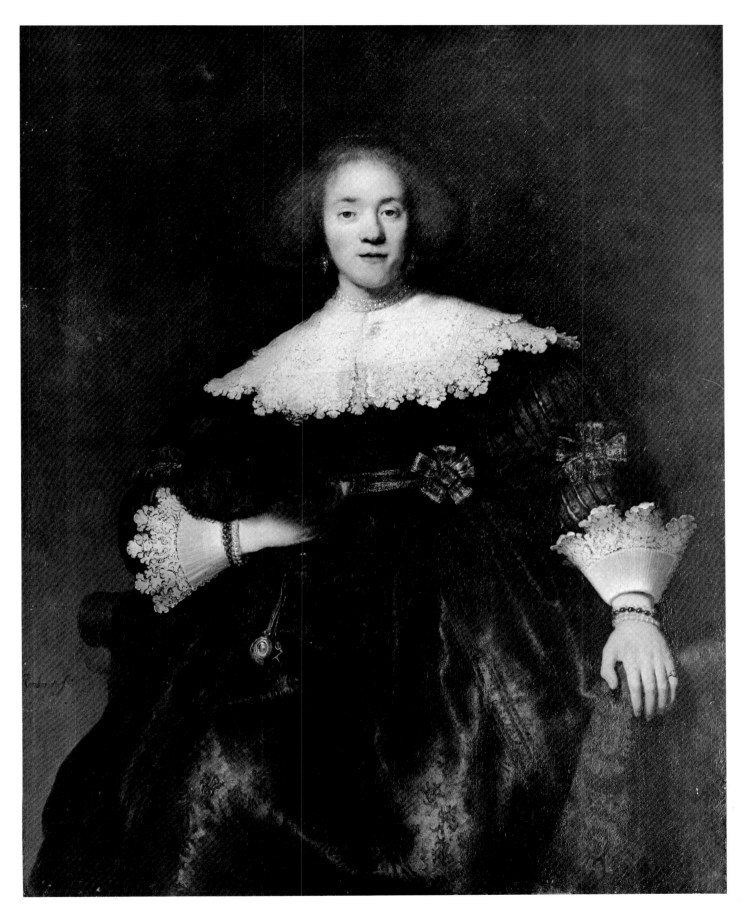

Plate 19. REMBRANDT HARMENSZ. VAN RIJN, *Portrait of a Lady with a Fan,* signed and dated 1633. Oil on canvas, 125.7 x 101 cm. (49½ x 39¾ in.). The Metropolitan Museum of Art, Gift of Helen Swift Neilson, 1943, 43.125

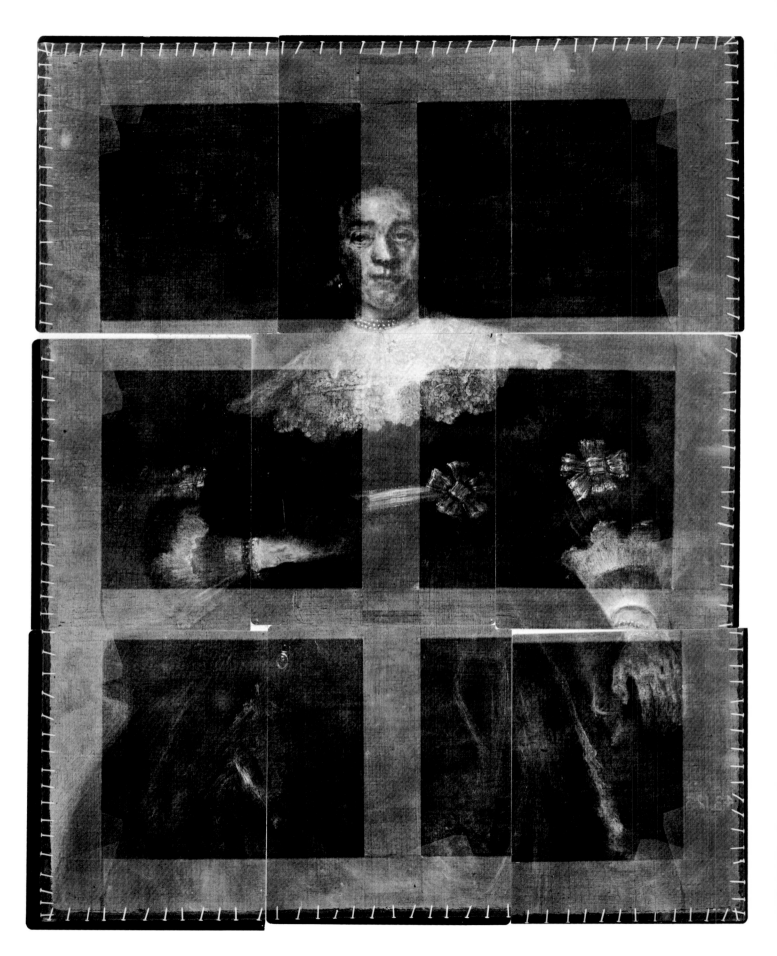

Plate 20. X-ray radiograph, *Portrait of a Lady with a Fan*

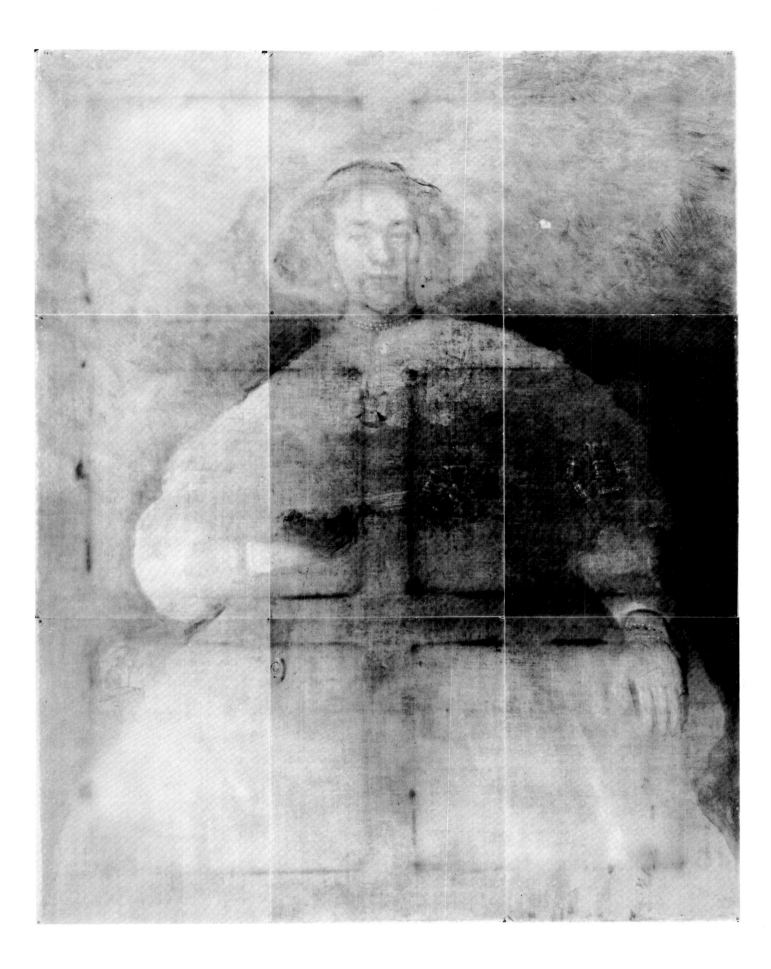

Plate 21. Third autoradiograph, *Portrait of a Lady with a Fan*

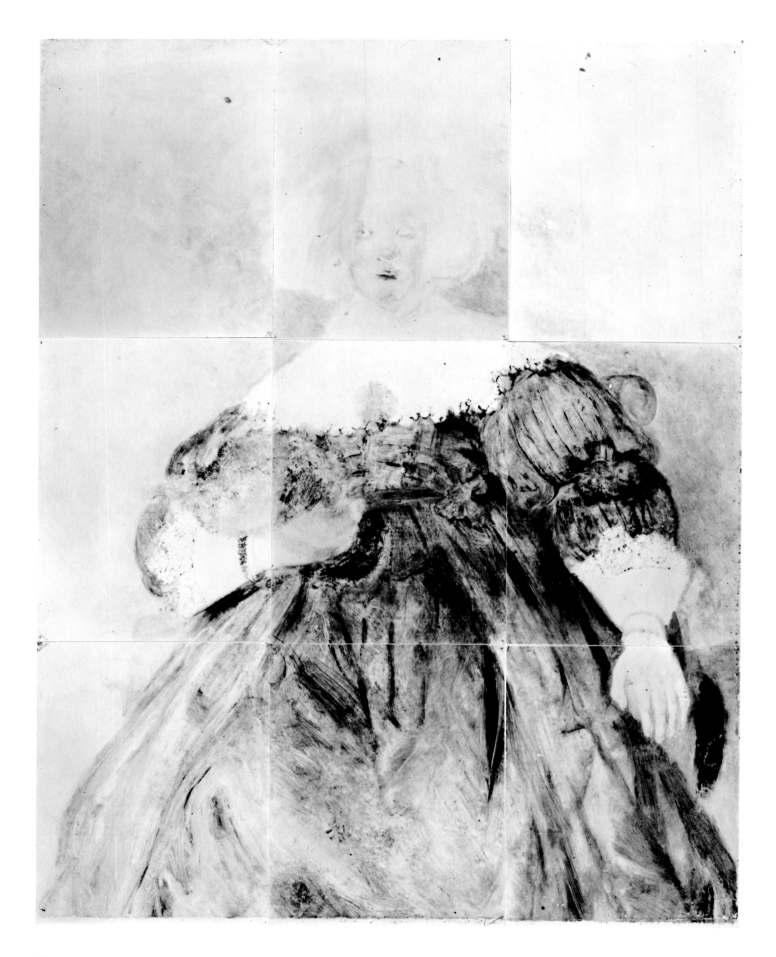

Plate 22. Eighth autoradiograph, *Portrait of a Lady with a Fan*

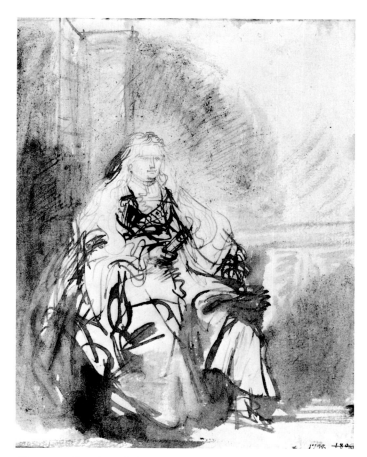

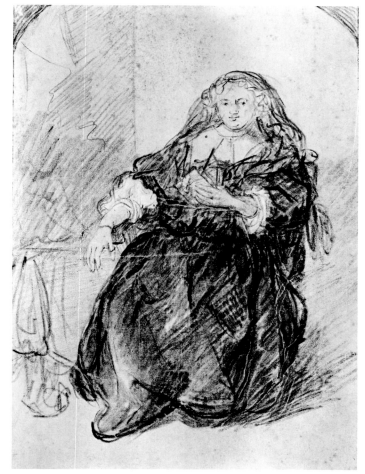

Figure 4. Rembrandt Harmensz. van Rijn, *Study for The Great Jewish Bride,* 1635. Pen and ink with wash, 24.1 x 19.1 cm. (9⅛ x 7⅛ in.). Nationalmuseum, Stockholm

Figure 5. Rembrandt Harmensz. van Rijn, *Saskia Seated in an Armchair,* ca. 1633. Black and white chalk, 26.5 x 19.0 cm. (10⅜ x 7½ in.). Kunsthalle, Hamburg, 21732

Totally in keeping with the technique of these early portraits is the more fanciful *Man in Oriental Costume (The Noble Slav)* of 1632 (Plate 23; X-ray radiograph, Plate 24). As in the male Beresteijn portrait (Plate 11), Rembrandt chose a background devoid of objects, concentrating instead on the handling of lights and darks. His working procedure in creating these effects can now be studied more effectively because of the clarity of brushwork revealed by autoradiography. In both paintings (Plates 14, 25) parallel hatching and multidirectional strokes occur in adjacent areas, achieving tonal variations much like those of Rembrandt's printmaking.

Again, only minimal adjustments were made in the contours of the figure. Plate 25 at the lower right shows the brushwork of the background filled in around the first established form, which was left in reserve. Later, during the stage when the figure was worked up, this area and the contour of the proper right shoulder were overpainted, edges strengthened, and the features of the face reinforced with strokes of vermilion (Plate 26).

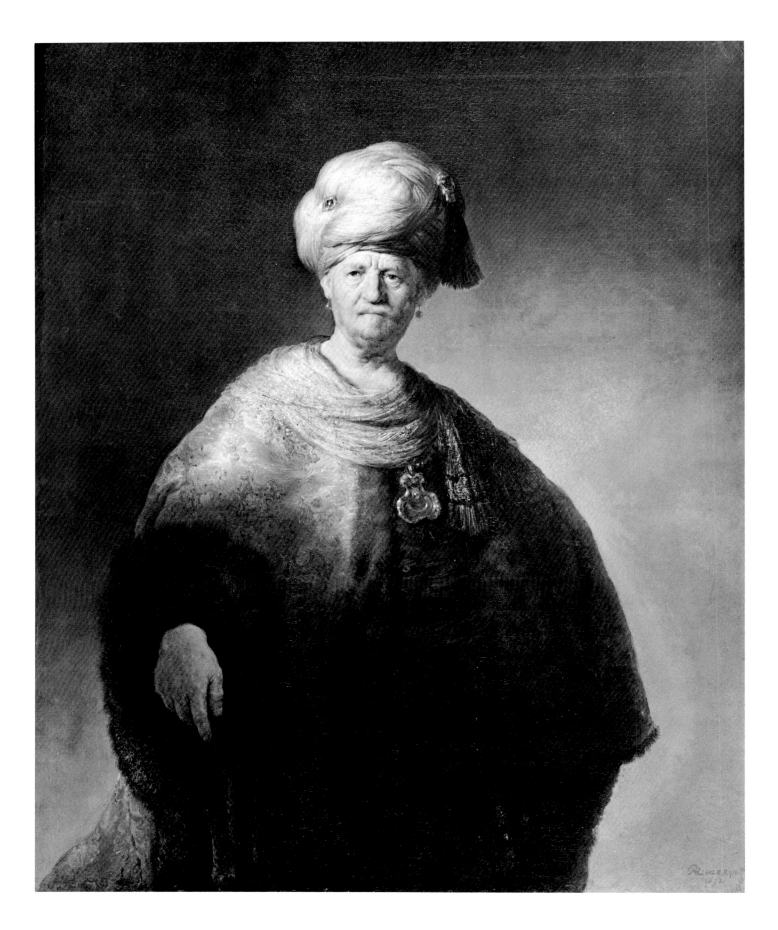

Plate 23. REMBRANDT HARMENSZ. VAN RIJN, *Man in Oriental Costume (The Noble
Slav)*, signed and dated 1632. Oil on canvas, 152.7 x 111.1 cm. (60⅛ x 43¾ in.).
The Metropolitan Museum of Art, Bequest of William K. Vanderbilt, 1920, 20.155.2

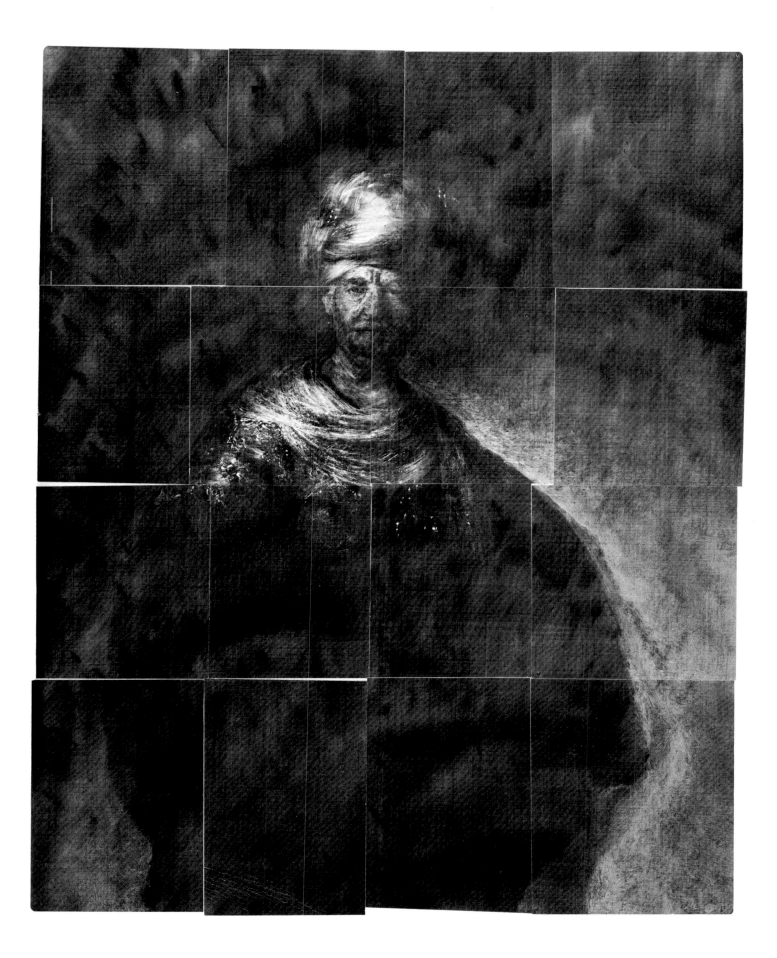

Plate 24. X-ray radiograph, *Man in Oriental Costume* (*The Noble Slav*)

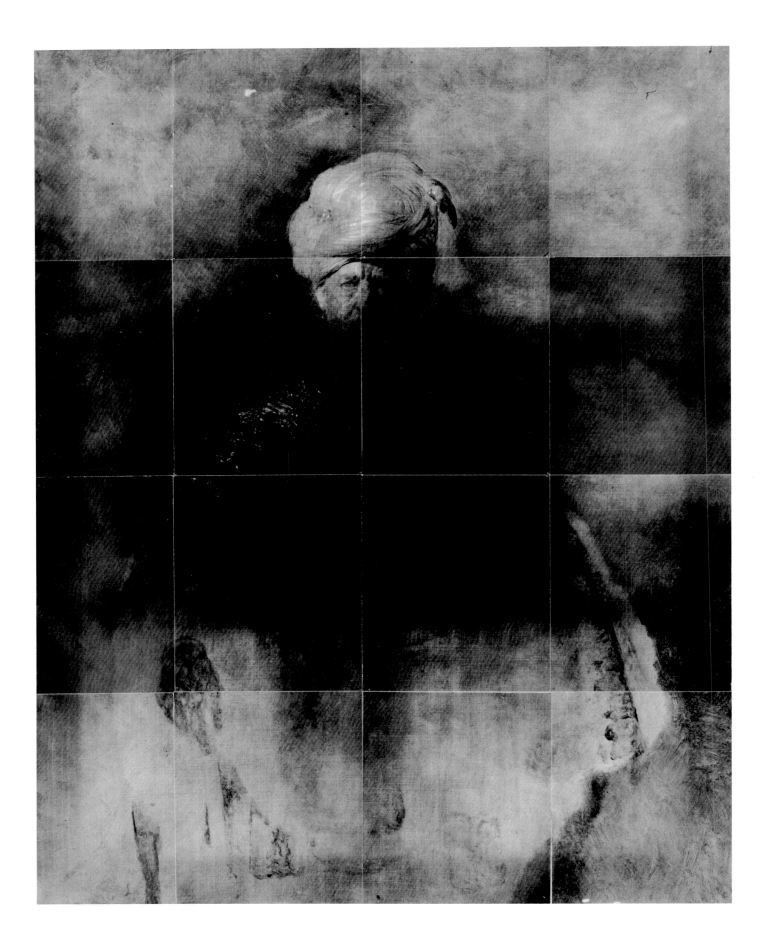

Plate 25. Third autoradiograph, *Man in Oriental Costume (The Noble Slav)*

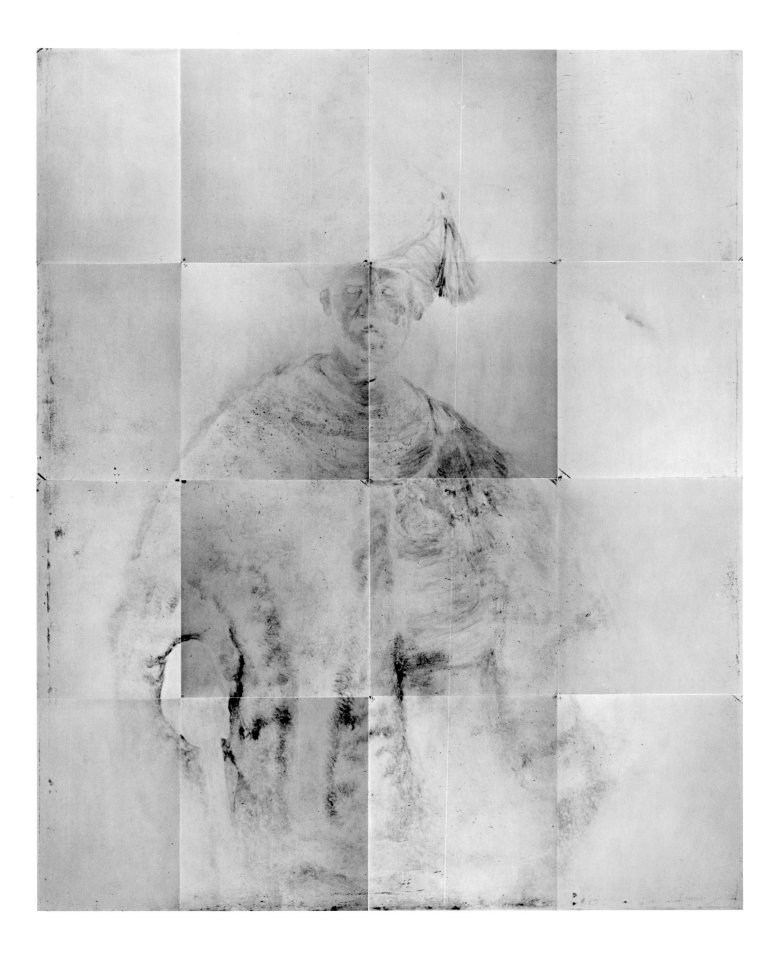

Plate 26. Seventh autoradiograph, *Man in Oriental Costume (The Noble Slav)*

For his 1633 painting of *Bellona* (Plate 27), Rembrandt laid aside the standard settings and stance of the *Lady with a Fan* and the female Beresteijn portrait in favor of a more ambitious design. This design was altered numerous times;[39] its evolution may be studied to a limited degree through X-ray radiography and to a far greater extent through autoradiography. The identity of the goddess was established in the early stages of the painting when Rembrandt placed the shield at the left, carried on the right arm so that the inside would show. The sword was held in the left hand. Little more than this information about the substituted positions of sword and shield and some vague shapes in the lower right corner can be obtained from the X-ray radiograph (Plate 28). Autoradiography substantiates these findings (shield in Plate 29; sword in the unillustrated third autoradiograph) and adds a good deal more about Rembrandt's working method.

Hidden from view until now was Rembrandt's rough sketch for his composition. In the autoradiographs it is visible in the Medusa head on the shield (Plate 29), in Bellona's face and right hand, and in a summary indication of the background bricks to the left of her head (Plate 30). The slight change in contour of the hair (Plate 29), which appears to be increased in fullness, indicates the blocking-out stage when the background is painted up to the contours of the figure. Autoradiography reveals some of the original character of the rapid working up of this background area in broad strokes (Plates 29, 30), now hardly visible to the naked eye, due to darkening and receding of these colors.

Plate 30 demonstrates how, in establishing the costume of the figure, Rembrandt clearly painted Bellona's decorative skirt with its deep slits first and then added the armor on top of it. He also sketched in the right hand before adding the glove. Changes were made in the upper part of the costume where a sash once fell over the shoulders, bosom, and right arm,[40] in the size of the plume of the helmet, and in the contour of the skirt hem.[41]

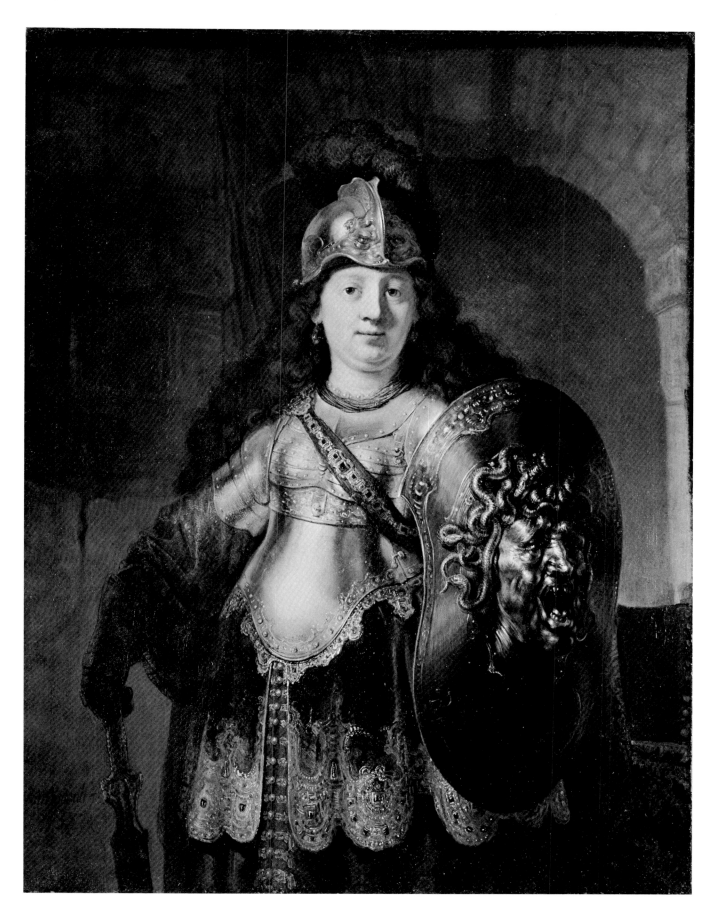

Plate 27. REMBRANDT HARMENSZ. VAN RIJN, *Bellona,* signed and dated 1633.
Oil on canvas, 127 x 97.5 cm. (50 x 38⅜ in.). The Metropolitan Museum of Art,
The Friedsam Collection, Bequest of Michael Friedsam, 1931, 32.100.23

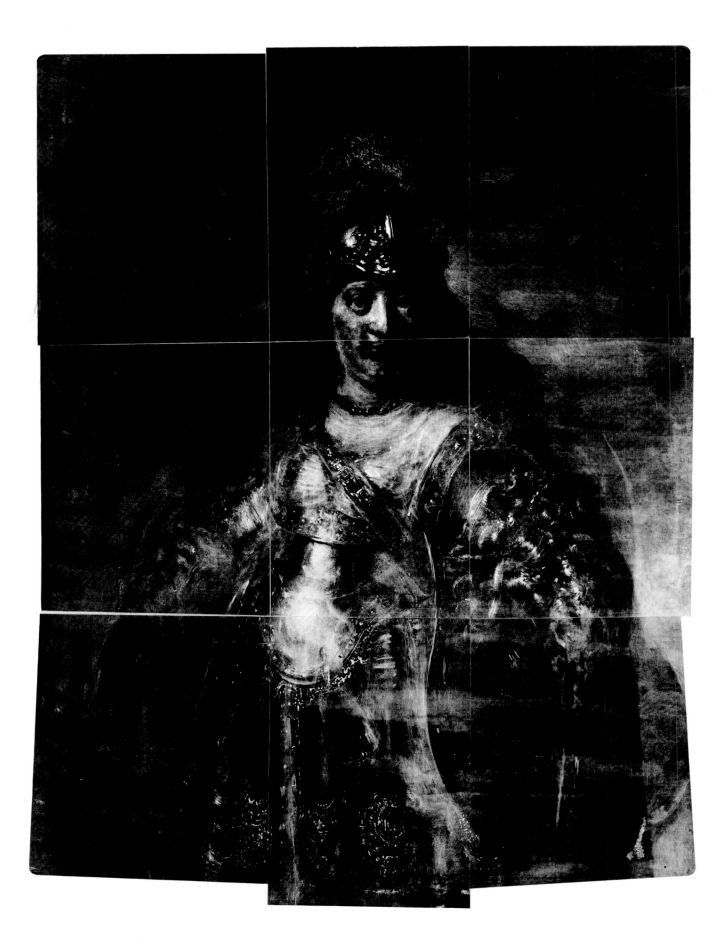

Plate 28. X-ray radiograph, *Bellona*

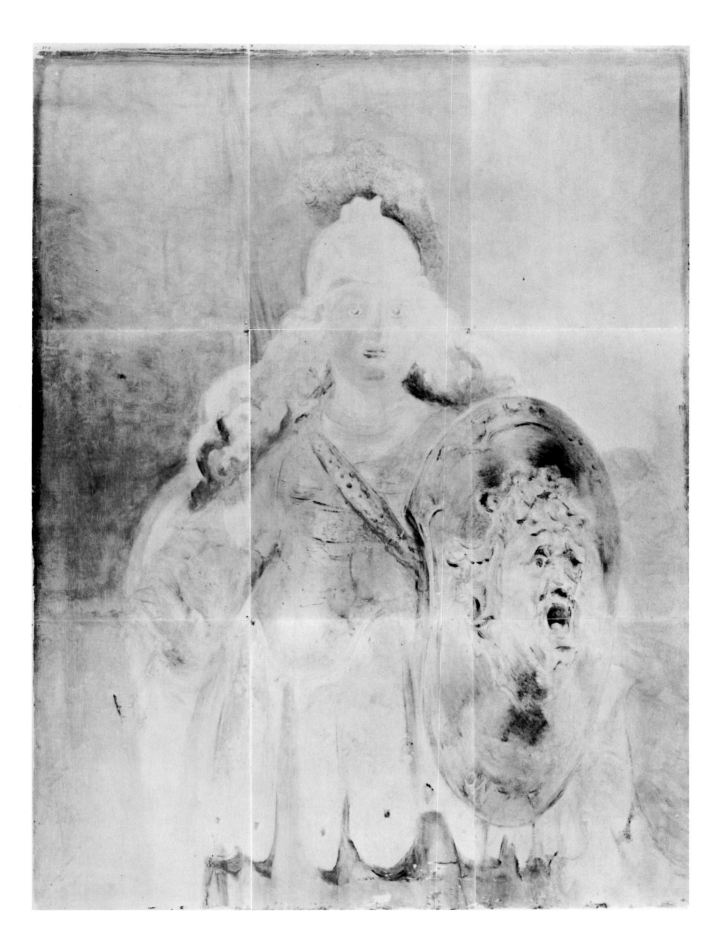

Plate 29. Eighth autoradiograph, *Bellona*

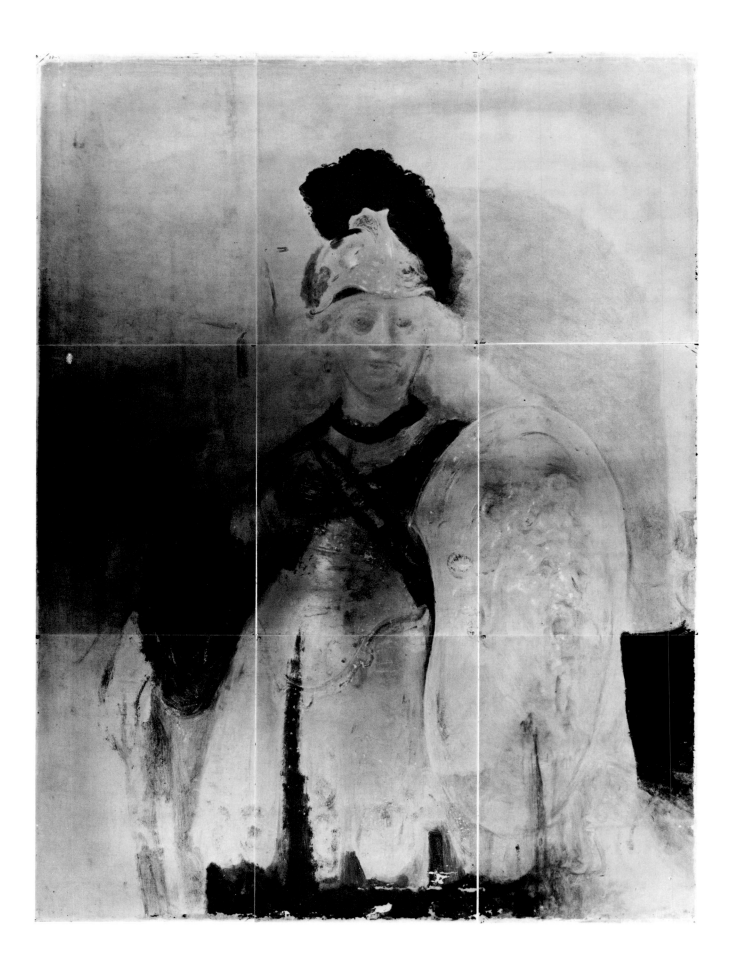

Plate 30. Fifth autoradiograph, *Bellona*

Much has been written about the history and subject of *Aristotle with a Bust of Homer* (Plate 31), which was commissioned by the Sicilian nobleman Antonio Ruffo in 1652.[42] Until now, however, details about the painting's technique and state of preservation have not been elucidated. Open to question was whether any original paint survived beneath the damaged black apron. Because this painting was to be cleaned, it was important to learn the true condition of this area before any restoration was undertaken. In this regard the X-ray radiograph (Plate 32) was of no assistance. Other than what is visible to the naked eye, the radiograph showed little about the painting except for the scraping marks of ground preparation or lining adhesive. The autoradiographs, on the other hand, indicate precisely the extent of the losses in the apron and hat (Plates 33, 34). The lightest portions in Plate 33, where the canvas weave is apparent, represent damage down to the first layer of ground and those slightly darker, adjacent areas to the second ground layer. Only small islands of original paint in the center of the apron are left. The losses seen in Plate 33 at the edges of the picture are on the back of the painting in the lead-white mixture that served as an adhesive in the lining.

Autoradiographs also show many stages of development in the painting that indicate Rembrandt's struggle to achieve satisfactory solutions. For the most part, the composition was established at the outset. There are few changes in the arrangement of objects in their setting. Rembrandt's ideas for the costume of Aristotle, however, were not firmly fixed. As a single autoradiograph shows many layers at once, it is only by comparison of the nine composite autoradiographs that one may follow the artist's procedure. Most information may be found in two of the series (Plates 33, 34). Plate 34 shows best Rembrandt's early idea for the costume, a dark tunic with close-fitting cap sleeves at the upper arm and fuller sleeves on the undergarment below. A slight tonal variation in the autoradiographs at Aristotle's left arm differentiates the earlier from the later and fuller sleeve. For this design the left arm was placed close to the body. The filling in of the background around this form is evidenced in the slightly darker tonal areas of the left sleeve and above the right arm and shoulder.

Rembrandt reworked the costume, sketching in another with fuller sleeves and higher shoulders. The vertical strokes on Aristotle's right arm (Plate 33) and some of those around the upper left arm indicate a preliminary and quickly abandoned notion. At this point, strokes for the background were filled in around the upper right arm at its new, higher level (Plates 33, 34).

For the final stage, Plate 33 shows how Rembrandt again sketched in his design as is seen in the marvelously free and direct drawing of the figure's left sleeve.[43] This position of the arm, now parallel to the picture plane, necessitated altering the placement of the left hand as well. Simultaneously, Rembrandt lowered the right shoulder to its original level. Though from the autoradiographs one may follow certain stages of costume change, this reading tends to simplify a process that actually may be more complicated. Cross-section analysis of Aristotle's left hand, for example, indicates multiple changes, not all of which may be accounted for in the autoradiographs.[44] It must be kept in mind that layering in other areas of Rembrandt paintings may be considerably more complex than the evidence of X-ray radiography or autoradiography reveals.

The sequence of alterations in the rest of the painting is not possible to establish. At one point the books behind the curtain at the left replaced what may have been a simpler vacant background (as in the diagonal stippling unrelated to the strokes for the books in this area, Plate 34). There are also pentimenti in the

hat of Aristotle and in a wall (chair back?) to the right behind the scholar. The position of the Alexander medal was changed, and the height of the bust of Homer (Plates 33, 34) altered.[45] The last of these is interesting for the history of the picture. Known once to have measured 8 by 6 *palmi,* this painting is now missing about fourteen inches from its vertical dimension.[46] Clearly most of the canvas is missing at the lower edge; otherwise, the bust with a base and the table edge of the previous design would have been situated too close to the bottom of the painting (Plate 34).

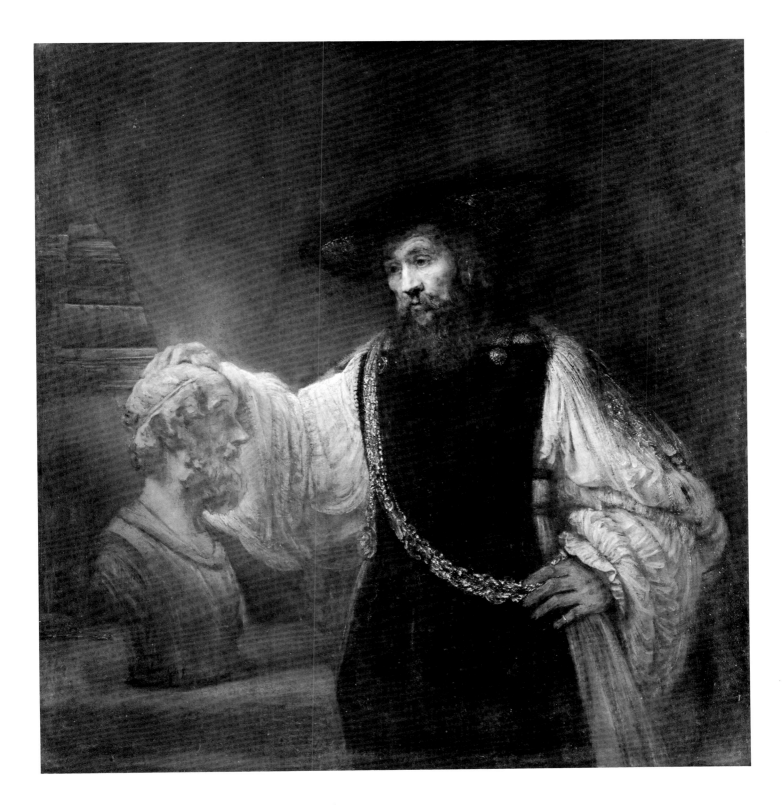

Plate 31. REMBRANDT HARMENSZ. VAN RIJN, *Aristotle with a Bust of Homer*, signed and dated 1653. Oil on canvas, 143.5 x 136.5 cm. (56½ x 53¾ in.). The Metropolitan Museum of Art, Purchased with special funds and gifts of friends of the Museum, 1961, 61.198

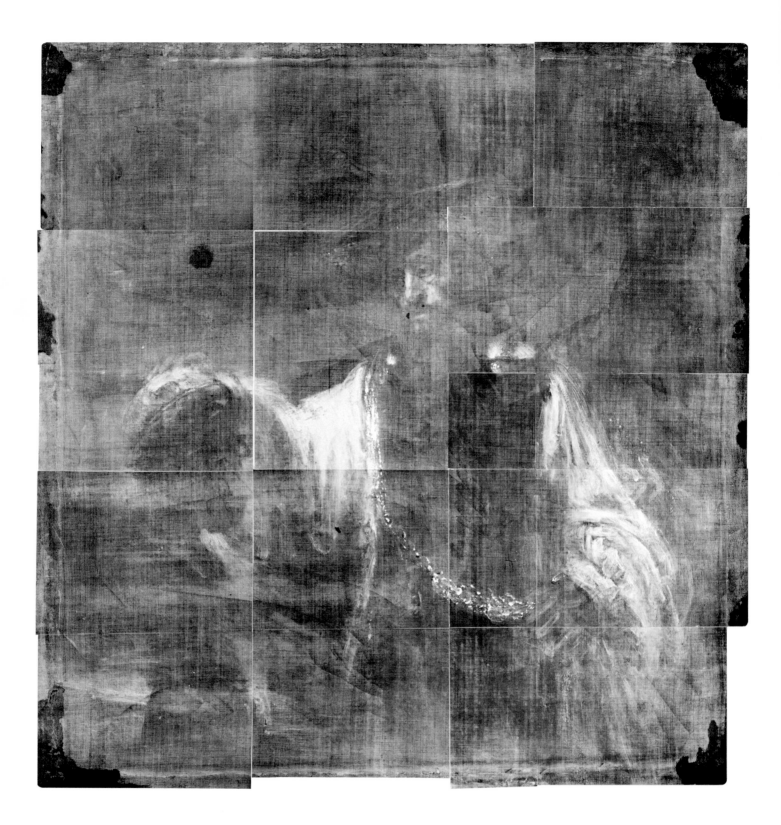

Plate 32. X-ray radiograph, *Aristotle with a Bust of Homer*

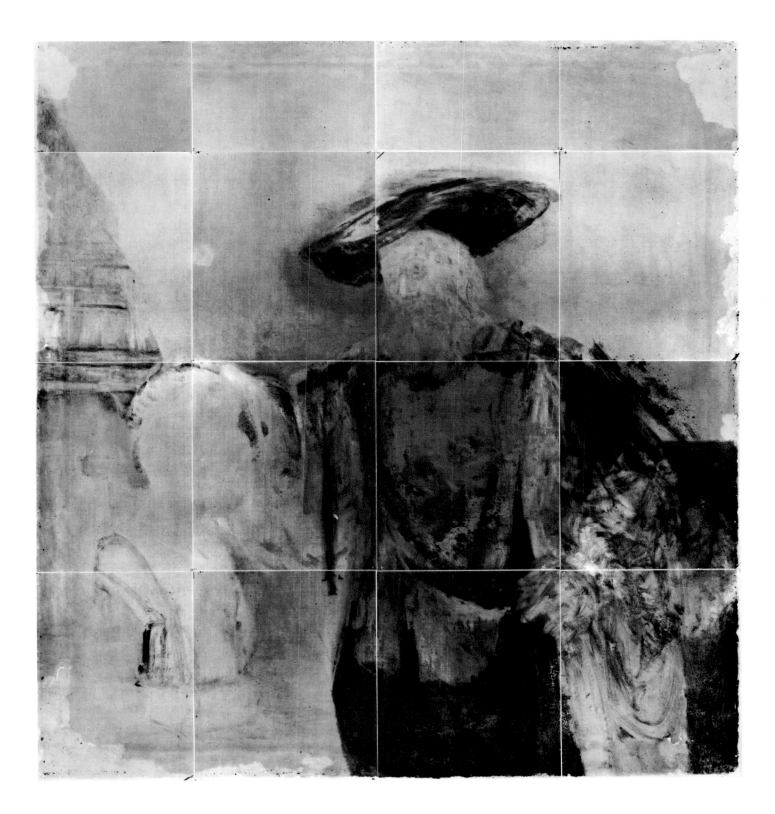

Plate 33. Sixth autoradiograph, *Aristotle with a Bust of Homer*

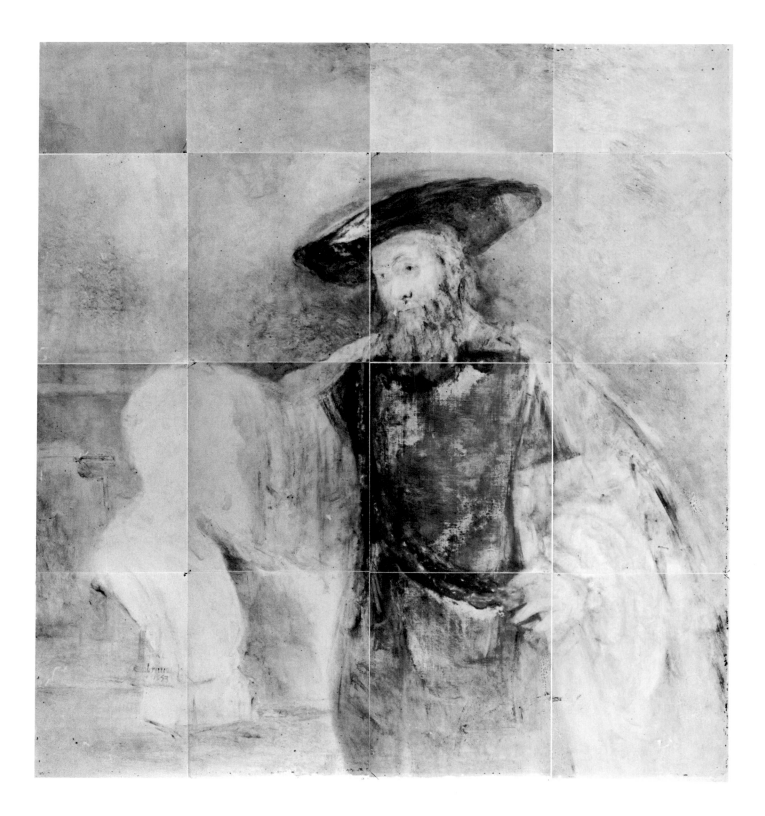

Plate 34. Eighth autoradiograph, *Aristotle with a Bust of Homer*

The Standard-Bearer (signed and dated 1654, Plate 35) has suffered greatly over time. The background in particular is very damaged along the edges, and the pigment has receded and darkened to a great extent. Autoradiography helps to clarify the original characteristics of the painting and reveals the particular importance the background area held for Rembrandt. He reworked it with considerably varied brushstrokes, here and there also using the butt end of the brush; at the upper left, he scraped a large portion of the paint away (Plate 37).[47] He apparently had painted this section wet-in-wet as is shown by the indistinct edges of the brushstrokes in the autoradiographs and confirmed by examination of paint cross sections.[48]

Not visible in the painting now, but recovered through autoradiography, is the varied brushwork of the figure (Plate 38), which complements the sophisticated technical working up of the background. Rembrandt framed the head by the paint-loaded vertical strokes of the flag behind it and created the sash of the torso with wide brush and spatula markings in horizontal and diagonal directions. At the right is the freer, more spontaneous working of the flag draped over the arm.

Emerging from the boldness and directness of these areas is the sensitive underpainted sketch for the face of the standard-bearer and numerous changes in the design of the hat (Plate 37). As in the autoradiographs of the Metropolitan Museum's 1660 *Self-Portrait,* the lightest hat shape is the final version. Comparable to the handling of the figure and its costume are two three-quarter-length pen-and-ink sketches of the early 1660s, the *Study of a Syndic* (Figure 6) and the *Portrait of a Man* (Figure 7).

Figure 6. Rembrandt Harmensz. van Rijn, *Study of a Syndic,* ca. 1660. Reed-pen and brush in brown ink with wash, 22.5 x 17.5 cm. (8⅞ x 6⅞ in.). Museum Boymans–van Beuningen, Rotterdam, R-133

Figure 7. Rembrandt Harmensz. van Rijn, *Portrait of a Man,* ca. 1662–65. Reed-pen and bister, white body color, 24.7 x 19.2 cm. (9¾ x 7½ in.). Musée du Louvre, Paris, Cabinet des Dessins, 22919

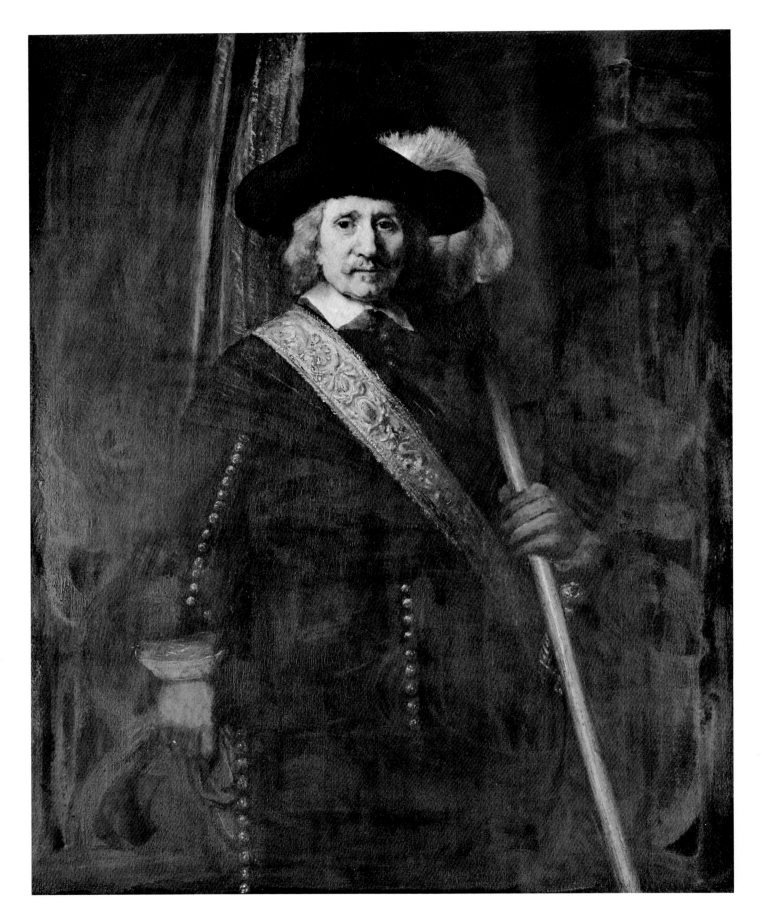

Plate 35. REMBRANDT HARMENSZ. VAN RIJN, *The Standard-Bearer,* signed and dated
1654. Oil on canvas, 140.3 x 114.9 cm. (55¼ x 45¼ in.). The Metropolitan Museum
of Art, The Jules Bache Collection, 1949, 49.7.35

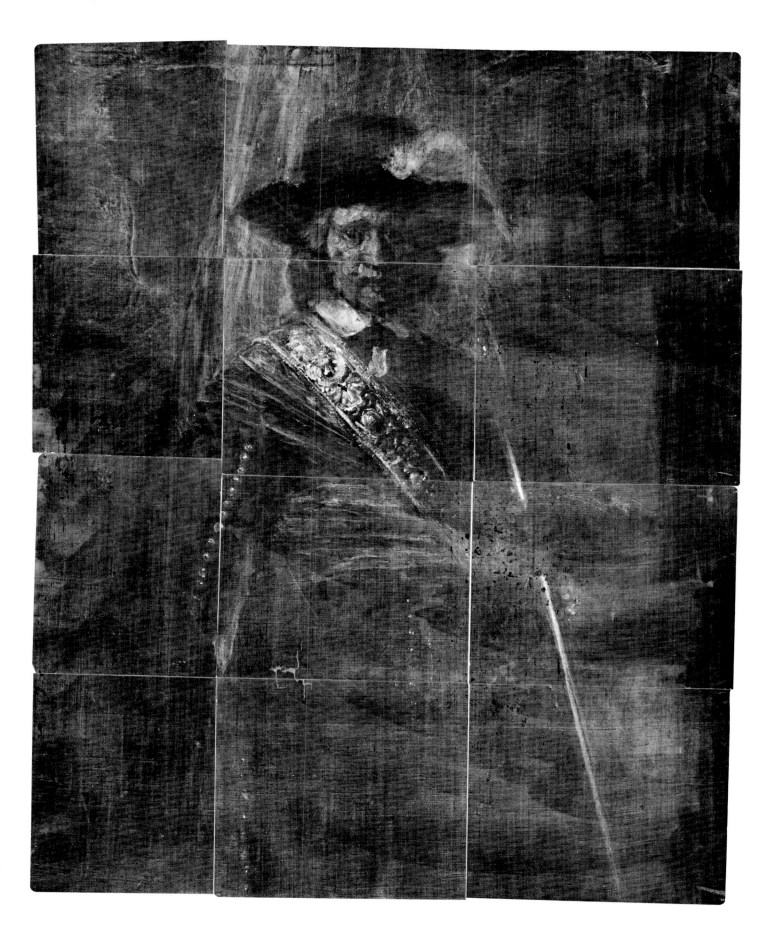

Plate 36. X-ray radiograph, *The Standard-Bearer*

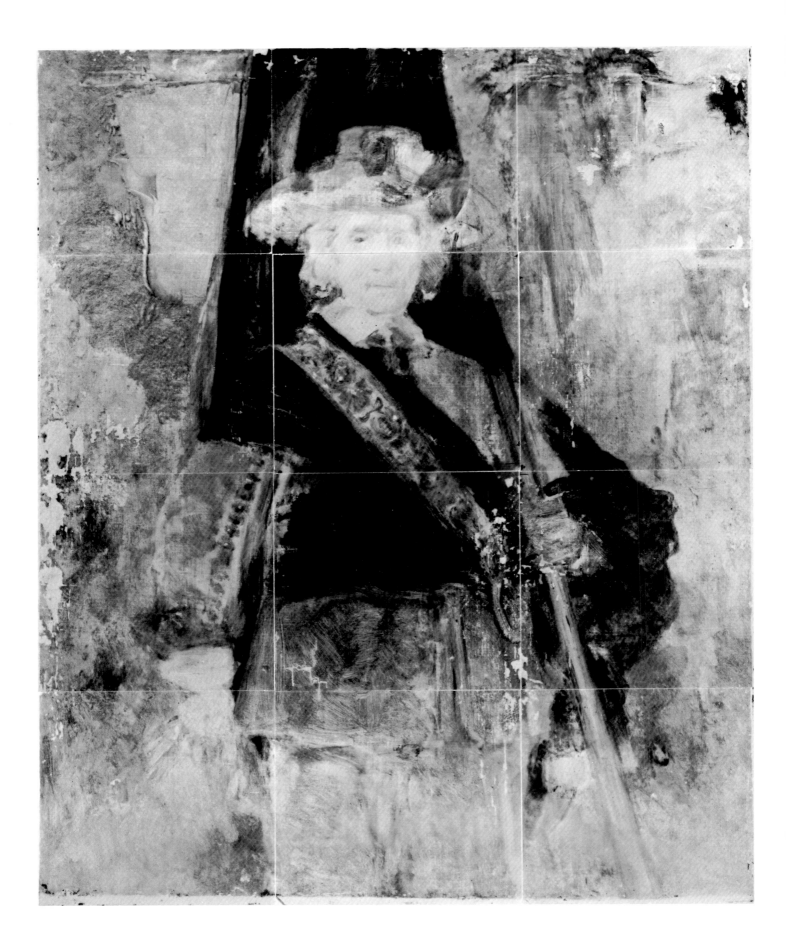

Plate 37. Sixth autoradiograph, *The Standard-Bearer*

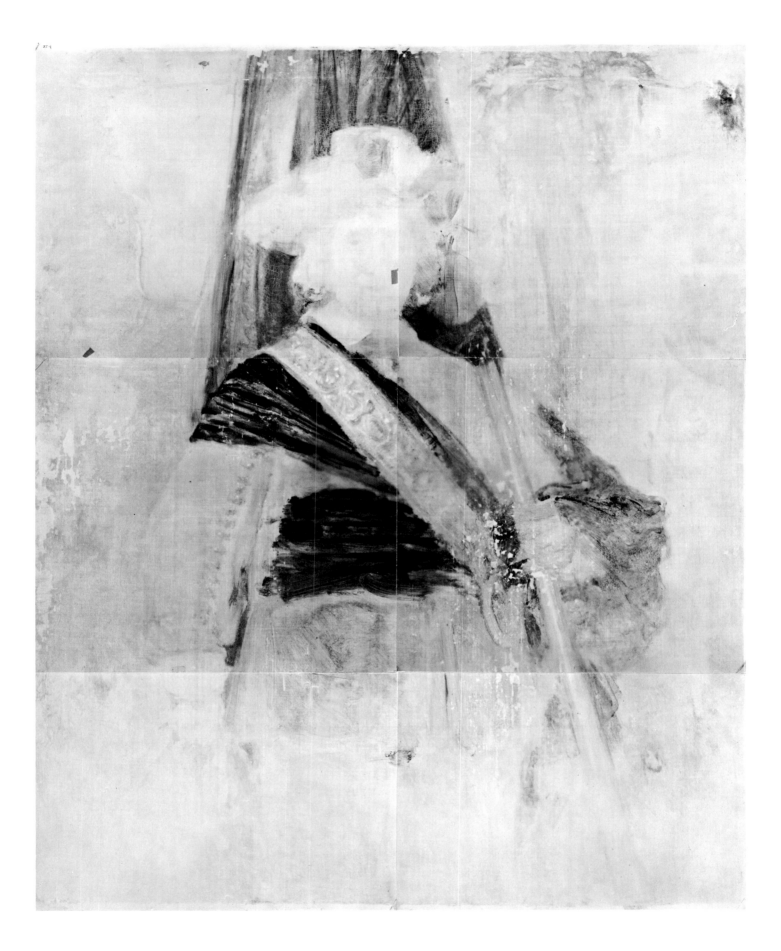

Plate 38. Fourth autoradiograph, *The Standard-Bearer*

The painted sketch in bone black for *Flora* (Plate 39) as visible in Plate 41 shows a summary indication of the features of the face, hands, and hair and a more fully worked out idea for the drapery.[49] About these aspects of the design Rembrandt was decided, and the artist's characteristic free and direct handling can be seen throughout this portion of the painting.

The autoradiographs alone reveal to what extent Rembrandt reworked the hat and background. In the first design (only a faint image of which can be seen in the painting and in the X-ray radiograph, Plate 40) the hat sat farther forward on the head. Lost to the naked eye are the brushwork in the hat and changes in its floral decorations (Plate 41). Certain autoradiographs, including Plate 41, clarify the pictorial structure of the background and show how Rembrandt created light effects. To the right, the use of stippling, multidirectional and zigzag strokes painted wet-in-wet, and scrapings with the butt end of the brush or fingernail achieved the rich tonal variety required. The background strokes come up to the face but do not directly follow its contour, demonstrating how freely Rembrandt worked around the sketch, filling in the background. He returned to the face afterward to establish the detail of Flora's striking profile in the upper paint layers.

Losses and abrasion along the vertical canvas join at the left side are most evident at the lower left (Plate 42), where a large portion was repainted in a mixture of yellow, brown, and red ochers and a coarsely ground black, all pigments consistent with seventeenth-century usage (possibly indicating an early damage and repair).[50] The tiny dark dots seen in the autoradiographs on the neck of the figure (Plate 41) are later restorations.

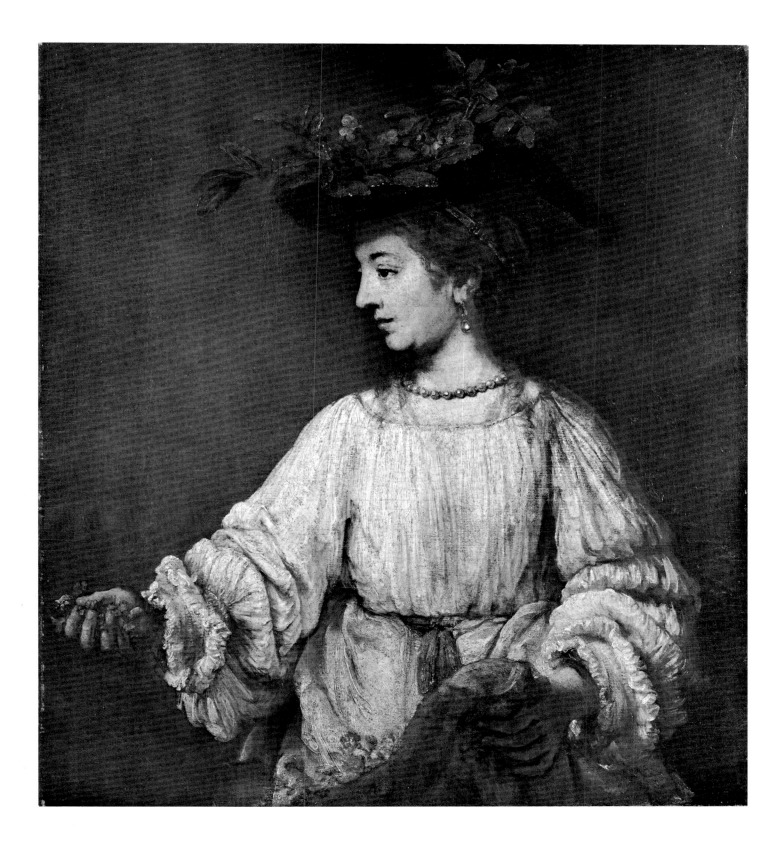

Plate 39. REMBRANDT HARMENSZ. VAN RIJN, *Flora,* ca. 1657. Oil on canvas, 100 x
91.8 cm. (39⅜ x 38⅛ in.). The Metropolitan Museum of Art, Gift of Archer M.
Huntington in memory of his father, Collis Potter Huntington, 1926, 26.101.10

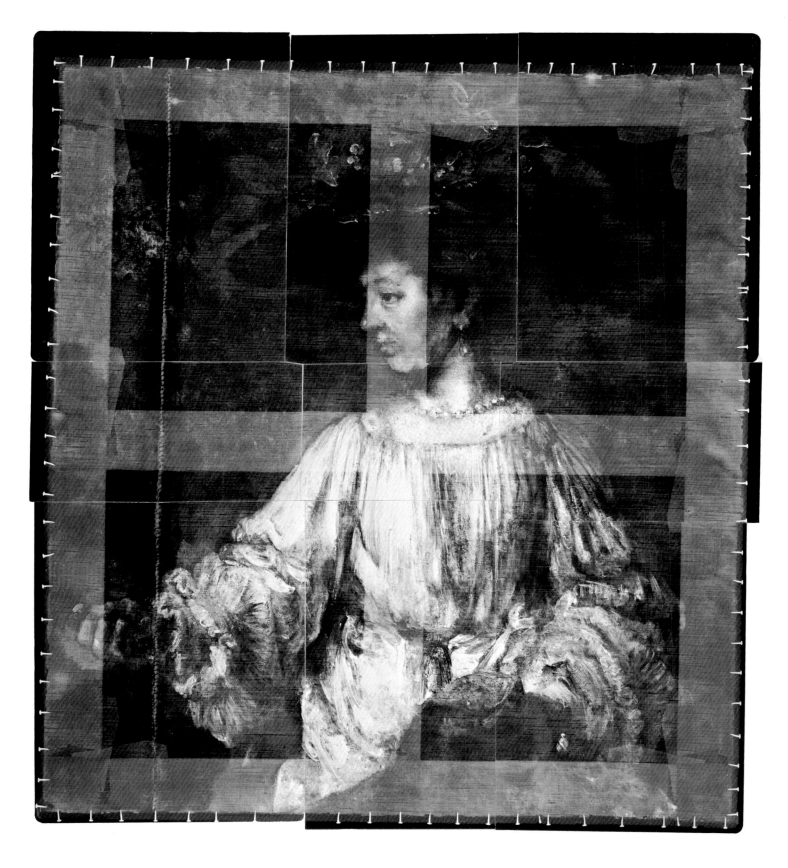

Plate 40. X-ray radiograph, *Flora*

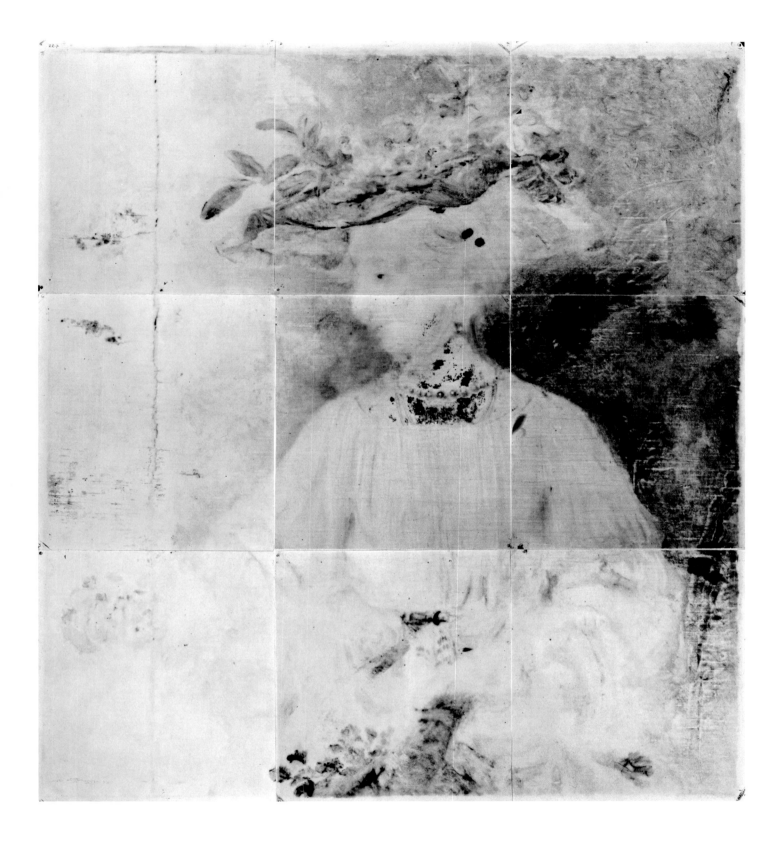

Plate 41. Seventh autoradiograph, *Flora*

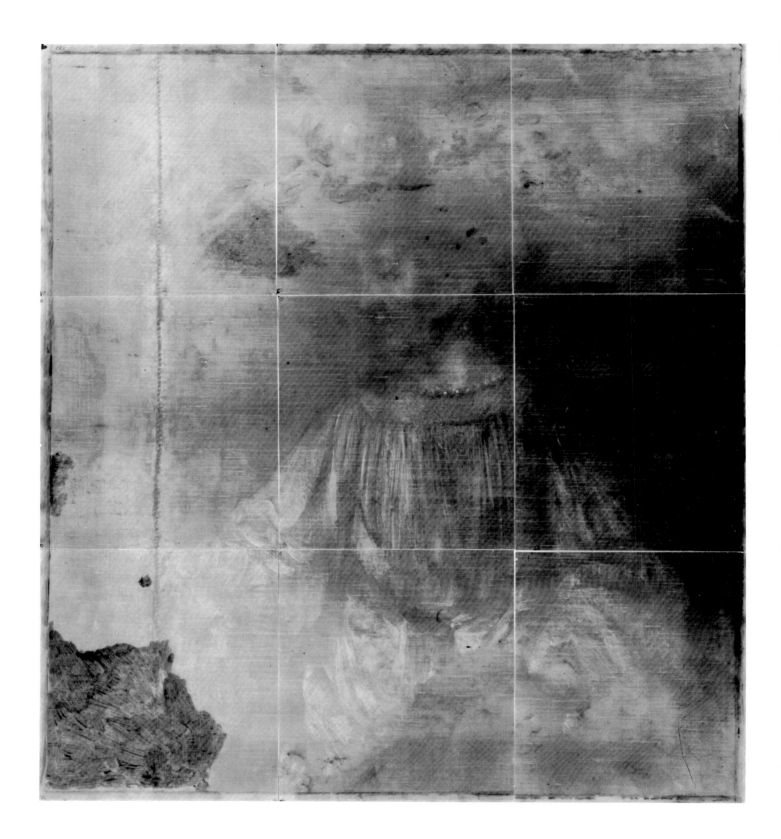

Plate 42. Second autoradiograph, *Flora*

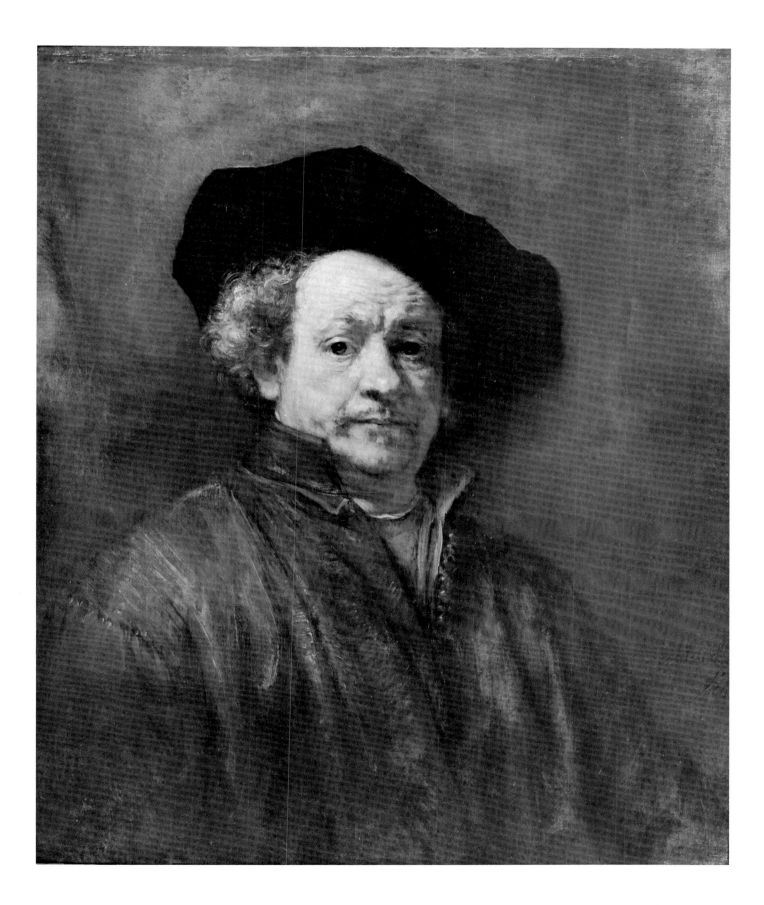

Plate 43. REMBRANDT HARMENSZ. VAN RIJN, *Self-Portrait,* signed and dated 1660.
Oil on canvas, 80.3 x 67.3 cm. (31⅝ x 26½ in.). The Metropolitan Museum of Art,
Bequest of Benjamin Altman, 1913, 14.40.618

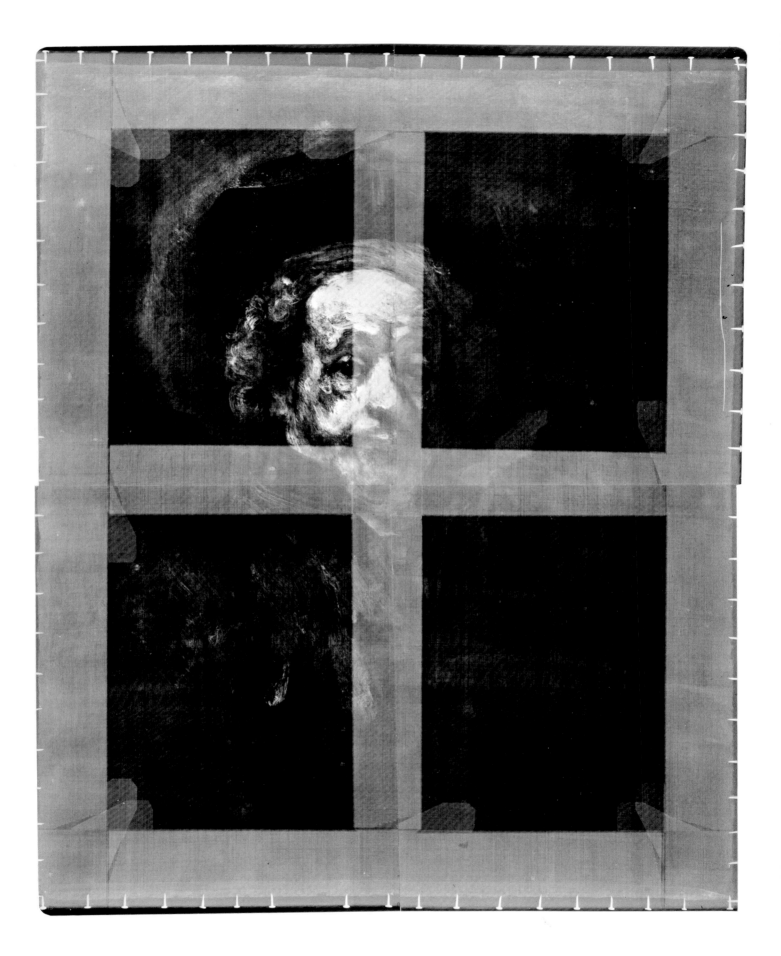

Plate 44. X-ray radiograph, *Self-Portrait*

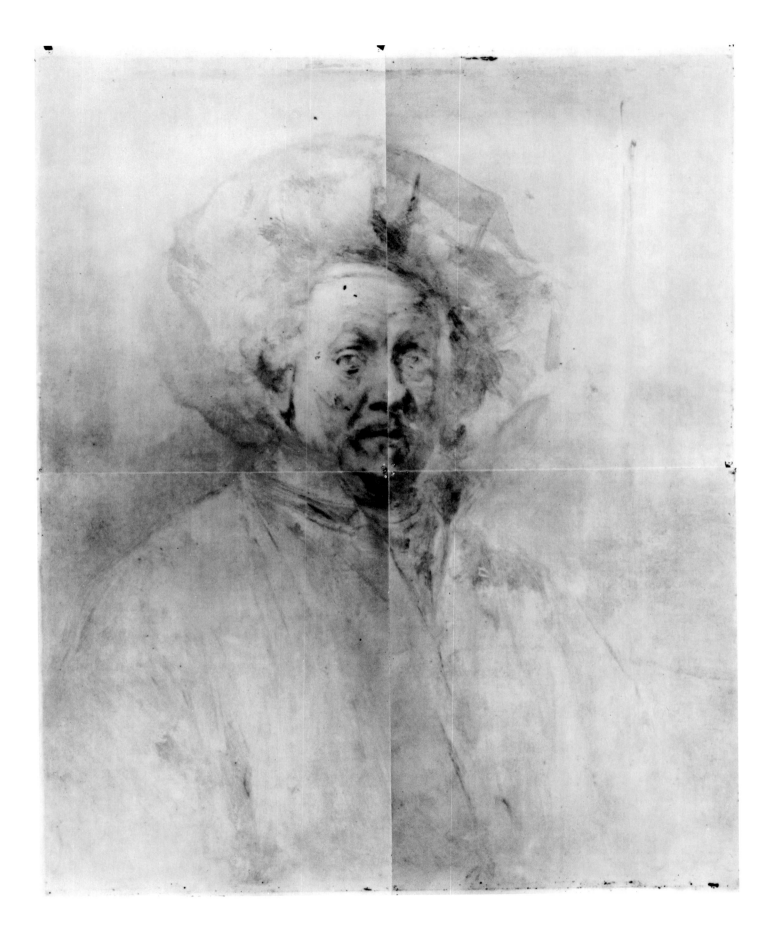

Plate 45. Fifth autoradiograph, *Self-Portrait*

The most significant finding in the autoradiographs of the 1660 *Self-Portrait* (Plate 43), and, indeed, one of the most important of this study, was the recovery of the preliminary sketch (Plate 45). This sketch is not duplicated in brushwork on the surface of the painting[51] and is not visible by any other means than autoradiography. The expressive spontaneity and freedom of the strokes forming the contours of head, hat, and body and defining the features of the face are directly comparable to contemporary self-portrait drawings in pen and wash. The head of the *Self-Portrait* in Figure 8 shows the same characteristic dashes and zigzag lines as the autoradiograph of Plate 45 in the cheeks, mouth, nose, eyes, and brows. Also similar are the thicker lines of a paint-loaded brush delineating the double chin. For the vigorous vertical strokes and shorthand method of drawing the solid body form in space (Plate 46), one may compare the powerful *Self-Portrait* in pen and ink (Figure 9) of about 1655–60.

To some extent pentimenti in the painting are visible to the naked eye in the area of the hat. The X-ray radiograph (Plate 44) also hints at changes. However, now for the first time, the hat motif is clearly discernible in perhaps as many as four shapes (Plates 45, 46).[52] These range in size from a painter's turban to a broad velvet hat with tassel, the lightest image in Plate 45 showing the final version of the painting. A parallel for the bold manner in which the volume and linear definition of the hat have been changed is found in a pen-and-ink drawing, *Rembrandt Himself* (Figure 10).

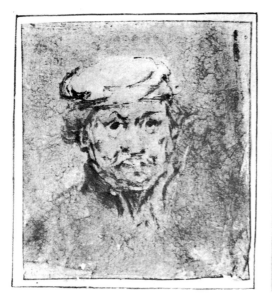

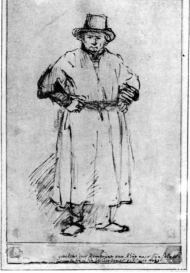

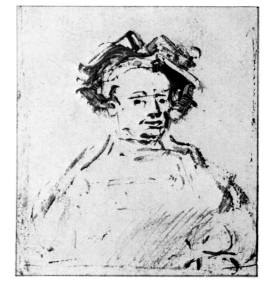

Figure 8. Rembrandt Harmensz. van Rijn, *Self-Portrait,* ca. 1660. Pen and bister, 8.4 x 7.1 cm. (3¼ x 2⅞ in.). Albertina, Vienna, 25449

Figure 9. Rembrandt Harmensz. van Rijn, *Self-Portrait,* ca. 1655–60. Pen and bister, 20.3 x 13.4 cm. (8 x 5¼ in.). Coll. Museum 'het Rembrandthuis', Amsterdam

Figure 10. Rembrandt Harmensz. van Rijn, *Rembrandt Himself,* ca. 1657–58. Pen and bister, 6.9 x 6.2 cm. (2¾ x 2½ in.). Museum Boymans–van Beuningen, Rotterdam, R-108

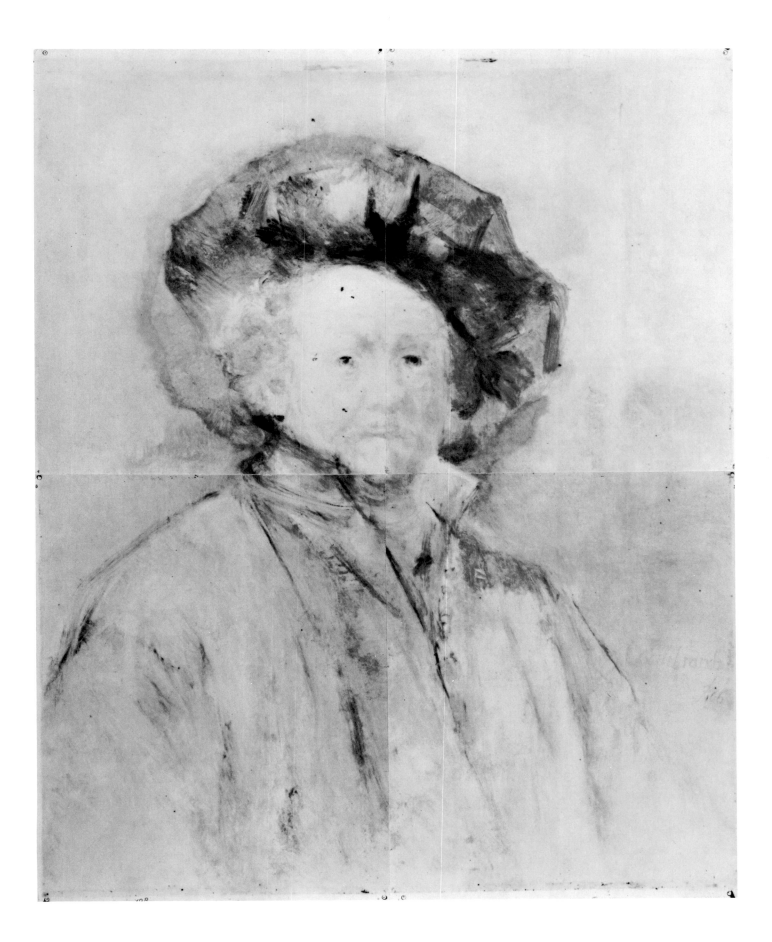

Plate 46. Eighth autoradiograph, *Self-Portrait*

Of the numerous questions posed by this painting (Plate 47), few can be answered by X-ray radiography and virtually none by infrared photography. Through autoradiography, however, Rembrandt's creative process can be more clearly understood.

The X-ray radiograph (Plate 48) gives only partial evidence of Rembrandt's effort to establish the form of the figure. Vaguely decipherable is an early stage in which Hendrickje adopted a Titianesque pose with her left hand at her breast and her right hand below it, holding a flower perhaps. The frenzied strokes of lead white at the right are difficult to relate to any known shape and may be a summary indication of drapery.[53]

Autoradiography more clearly defines the evolution of the portrait. The bone-black sketch for the head (Plate 49) shows a thinner face that has been altered along the outline of the cheeks and jaw, and about the mouth and eyes (compare Plates 47, 49, 50).[54] Also visible is the drawing of the left hand at the breast and the confusing shape of the other hand below it. Accompanying this attitude of the hands was a blouse open at the breasts and a necklace pulled over and tucked into the garments at the right side (Plate 49).[55]

Not now visible to the naked eye is Rembrandt's method of creating tonal effects by scraping, as in the area to the left of the head (Plate 49), and by the animated brushwork of the background. These background strokes go up to the first established shape for the torso; in Plate 49, the lightest form at the contours of the shoulders and the far right edge is part of the portion left in reserve for subsequent working up.

This painting was transferred from canvas to canvas and possibly relined several times. As a result, it has suffered greatly. There are indications, however, that the picture may be unfinished. Neither the X-ray radiograph nor the autoradiographs define well the lower portion of the painting, especially in the area of the right hand. Clearly Rembrandt's attention was on the face, which he reworked in order to achieve its poignant expression. Perhaps he abandoned the rest.[56] The original dimensions of the painting did not include the strip at the left in Plate 49, which received a ground preparation only and no upper layers.

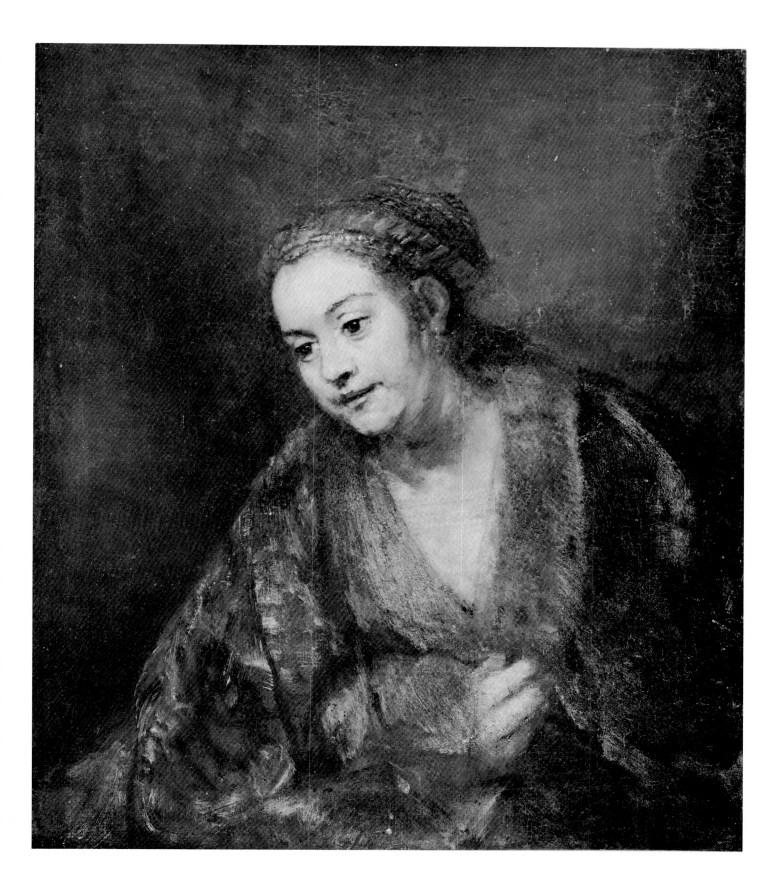

Plate 47. REMBRANDT HARMENSZ. VAN RIJN, *Hendrickje Stoffels,* signed and dated
1660. Oil on canvas, 78.4 x 68.9 cm. (30⅞ x 27⅛ in.). The Metropolitan Museum of
Art, Gift of Archer M. Huntington in memory of his father, Collis Potter Huntington,
1926, 26.101.9

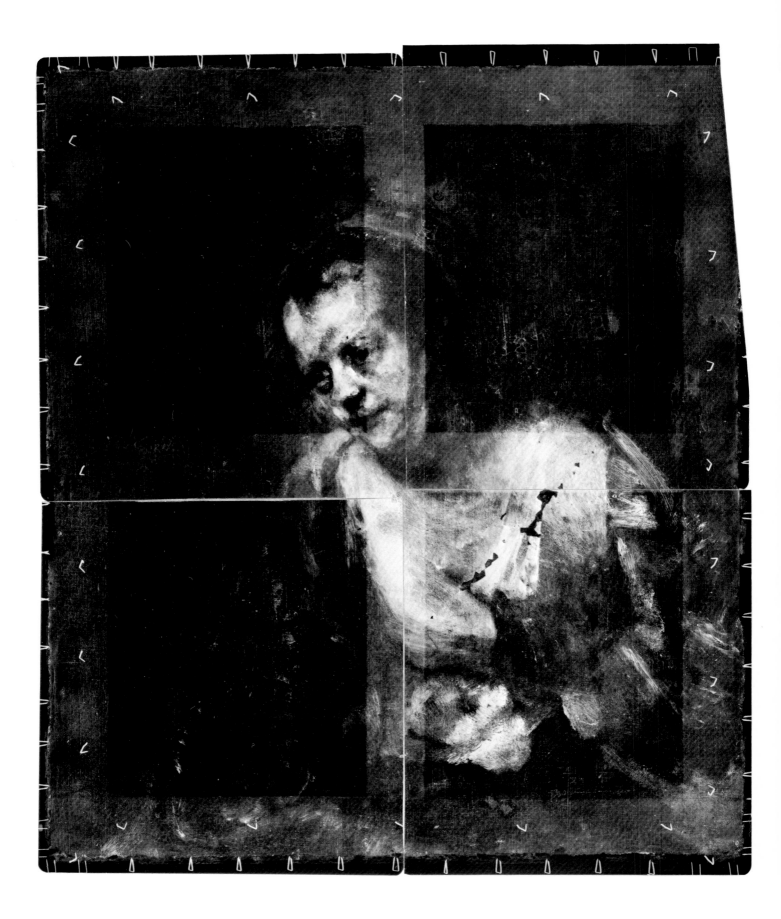

Plate 48. X-ray radiograph, *Hendrickje Stoffels*

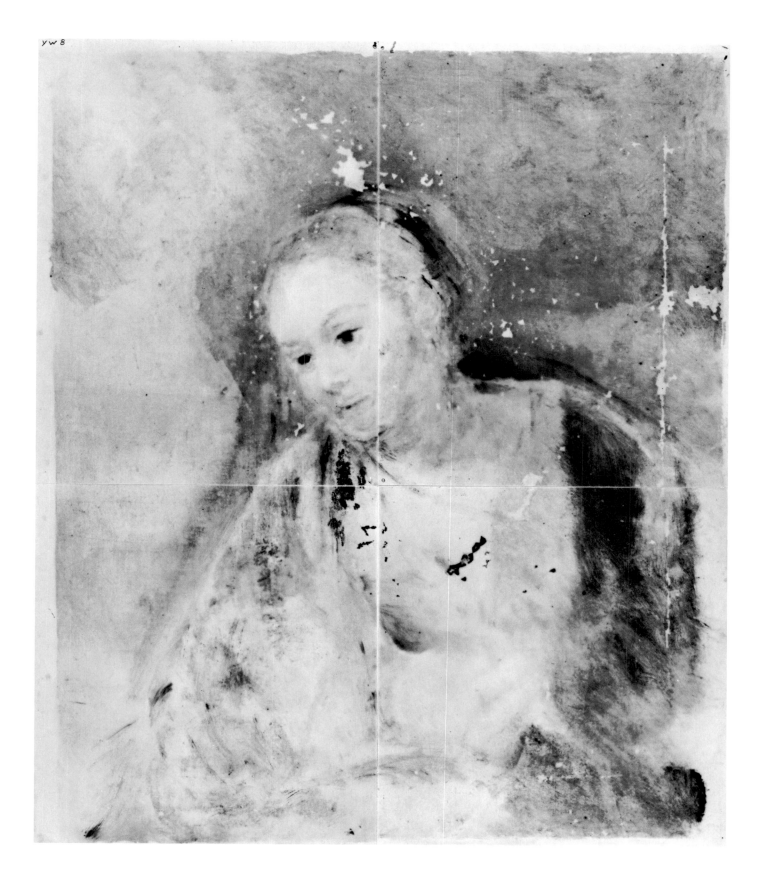

Plate 49. Eighth autoradiograph, *Hendrickje Stoffels*

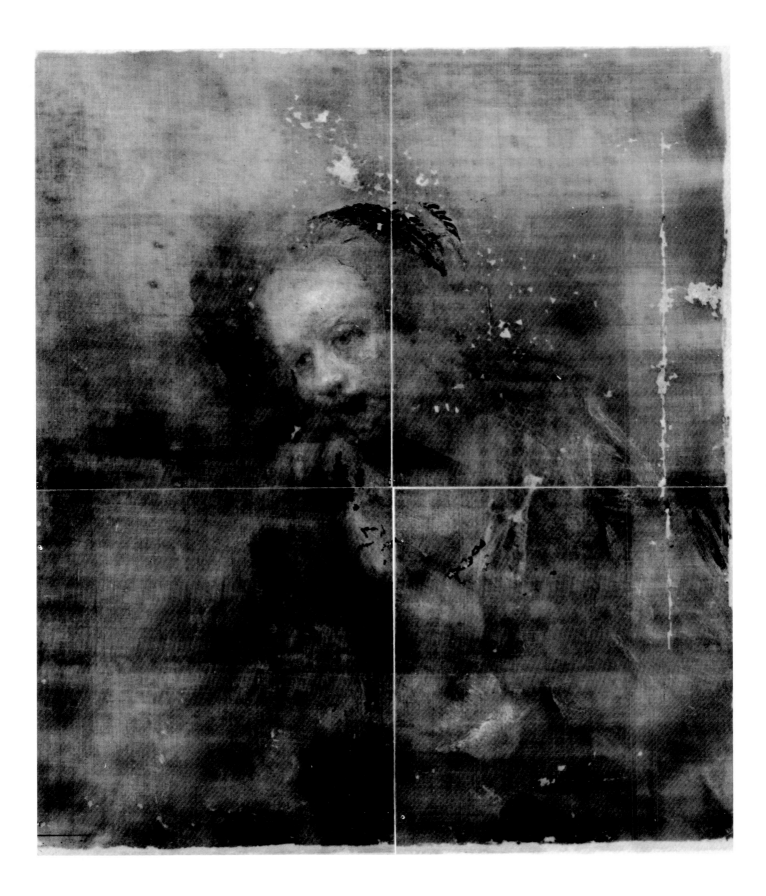

Plate 50. Fifth autoradiograph, *Hendrickje Stoffels*

Formerly hidden from view, the painted sketch in bone black for the *Man with a Magnifying Glass* (Plate 51) is now visible in autoradiographs (Plate 53). Cross-section analysis pinpoints it directly on top of the prepared ground.[57] Of special significance is the fact that this image cannot be seen by any other means; no hint of it exists in the X-ray radiograph (Plate 52).

The spontaneity and masterly authority of the brushwork in the costume, face, and hair may best be compared with Rembrandt's pen-and-wash drawings of the same period. The *Three Officials of the Drapers' Guild* of about 1660 (Figure 11) is similar to the portrait's underpainted sketch in its concentration on essential forms, angular strokes, and shorthand means of expressing facial features. Even the summary indication of background space by a few strokes is echoed in the upper left of the Museum's painting, where Rembrandt used a palette knife to apply paint (Plate 54).[58] Two other drawings, the *Study of a Syndic* (Figure 6) and *Portrait of a Man* (Figure 7), are also remarkably close in technique and visual effect to the underpainting.

In the preliminary design (Plate 53), the sitter's costume is presented in its simpler form before decorative additions of slit sleeves, necklace, and dark shirt directly under the collar. The full sleeves extend here to the edges of the canvas, and the left arm meets the right in clasped hands resting on a ledge (Plates 52, 54). Later a pillow was added beneath the right hand and the left arm was moved to a position at the side of the figure (Plates 51, 54).

The pigment in the background of this painting has receded and darkened to the extent that individual strokes are no longer visible. Through the technique of autoradiography, the rich working of multiple superimposed brushstrokes is now visible (Plate 53). As in his etchings, Rembrandt used stippling and long, disengaged strokes for the creation of tonal variety. Also apparent is Rembrandt's experiment with a vertical framing element at the left and an arched one at the top (Plate 53). This feature is complemented by a similar arch and framing element at the right in the painting's pendant, the *Lady with a Pink*.

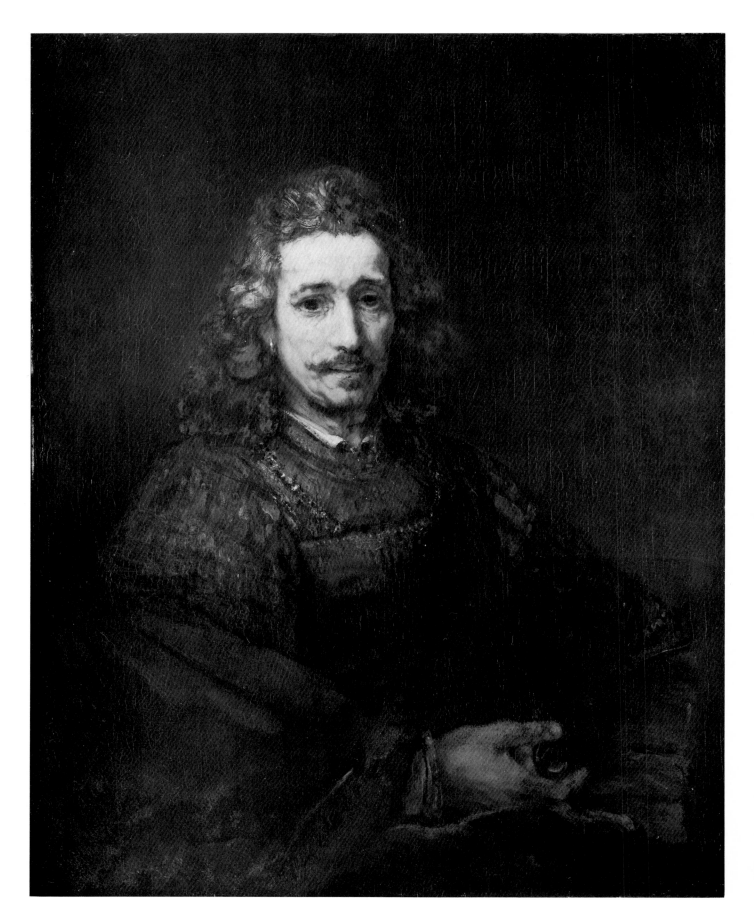

Plate 51. REMBRANDT HARMENSZ. VAN RIJN, *Man with a Magnifying Glass,* ca. 1663.
Oil on canvas, 91.4 x 74.3 cm. (36 x 29¼ in.). The Metropolitan Museum of Art,
Bequest of Benjamin Altman, 1913, 14.40.621

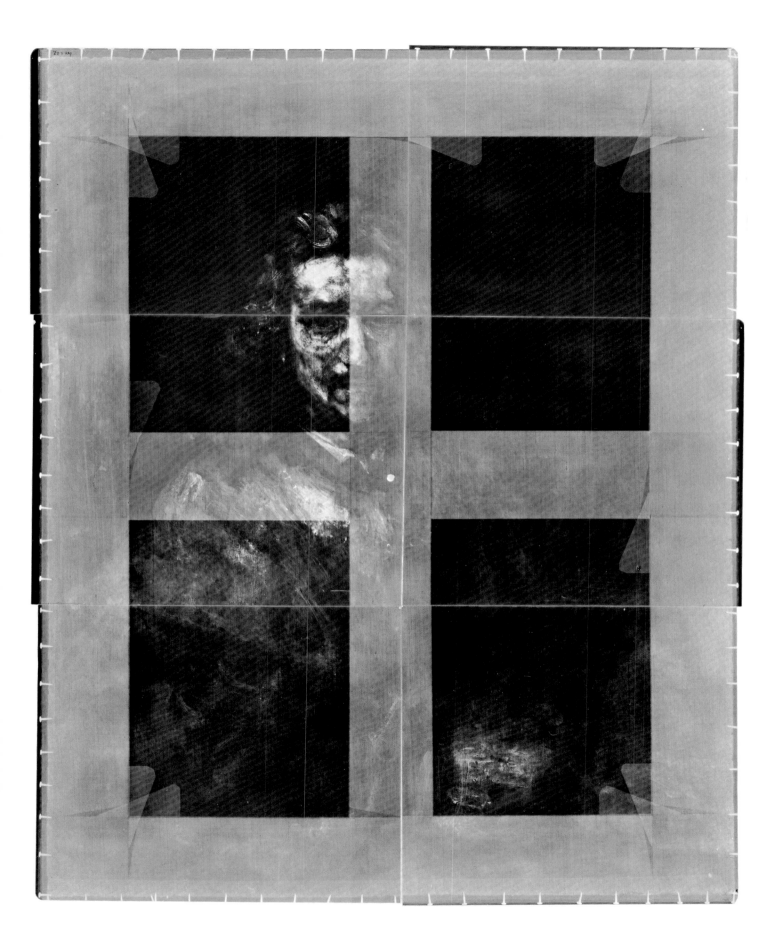

Plate 52. X-ray radiograph, *Man with a Magnifying Glass*

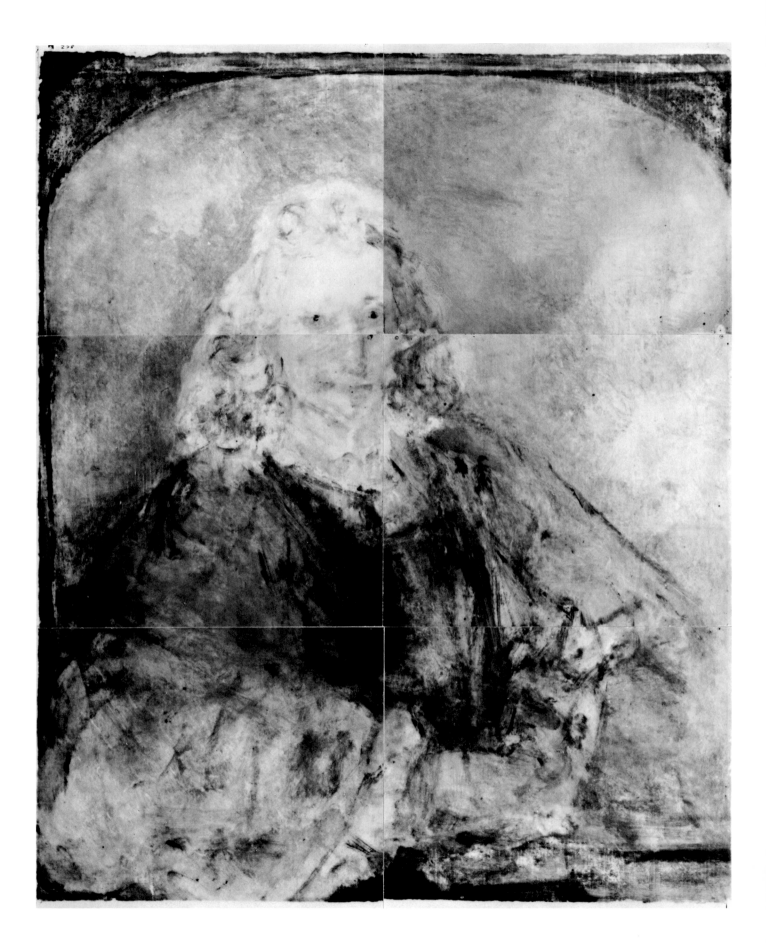

Plate 53. Eighth autoradiograph, *Man with a Magnifying Glass*

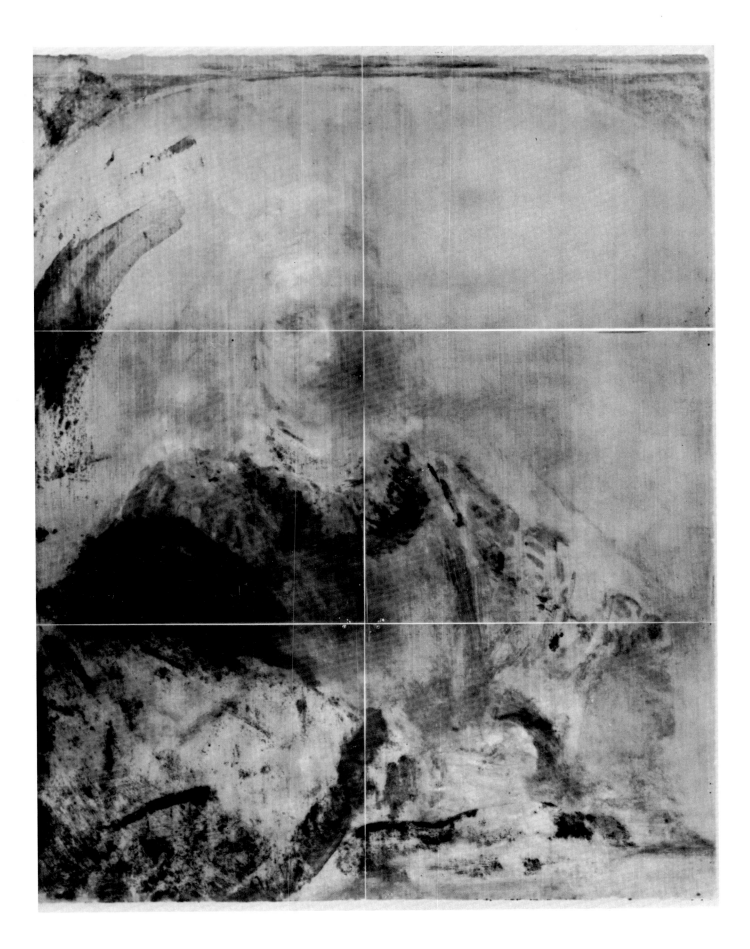

Plate 54. Sixth autoradiograph, *Man with a Magnifying Glass*

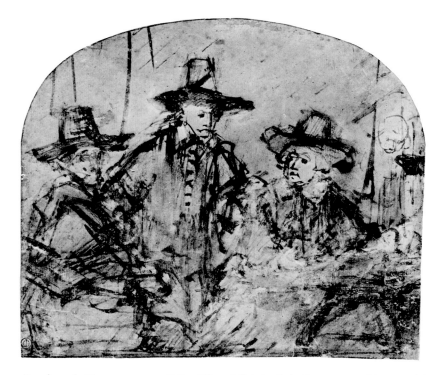

Figure 11. Rembrandt Harmensz. van Rijn, *Three Officials of the Drapers' Guild,* ca. 1660. Reed-pen and bister, wash, white body color, 17.3 x 20.5 cm. (6⅞ x 8⅛ in.). Staatliche Museen Preussischer Kulturbesitz, Kupferstichkabinett, Berlin, KdZ 5270

Lady with a Pink

Again exemplifying Rembrandt's different approach for male and female sitters, the *Lady with a Pink* (Plate 55) is more complex than its pendant in the costume of the sitter and in the background. For the most part, the pentimenti are of little consequence. They may be seen in the slight position change of the hands, head, and sitter's left sleeve (Plate 57). A major pentimento in question for some time has been the head of a child in the lower left, which appears in the X-ray radiograph (Plate 56) and not in the final version of the painting. Autoradiography shows that the head, which was never developed beyond a sketch in flesh tones,[59] was painted out at an intermediary stage, not after the completion of the painting as has been supposed (Plate 57).[60] In cross-section analysis the head appears directly on top of the ground, is blocked out by strokes of a transparent brownish black pigment (which also abut the woman's hands, Plate 58), and then is overpainted with the brownish red layer that blankets the lower left of the painting (Plate 57). More examples are needed to determine whether or not what appears to be a change in the expression of the woman's face, especially around the mouth, is simply Rembrandt's juxtaposition of strokes to form the shape of the mouth.

Autoradiography of this painting also aids in reading the area surrounding the figure. It clarifies the shape of the pillow on the ledge (Plate 58) and shows Rembrandt's rejected idea of the arch motif and vertical framing element at the right (Plate 57). As in the pendant, the background at the left appears as a network of varied strokes. The painting within a painting, indecipherable to the naked eye, appears above as a barely discernible landscape. It is balanced at the right by the broad scraping marks in the rendering of the curtain (Plate 57).

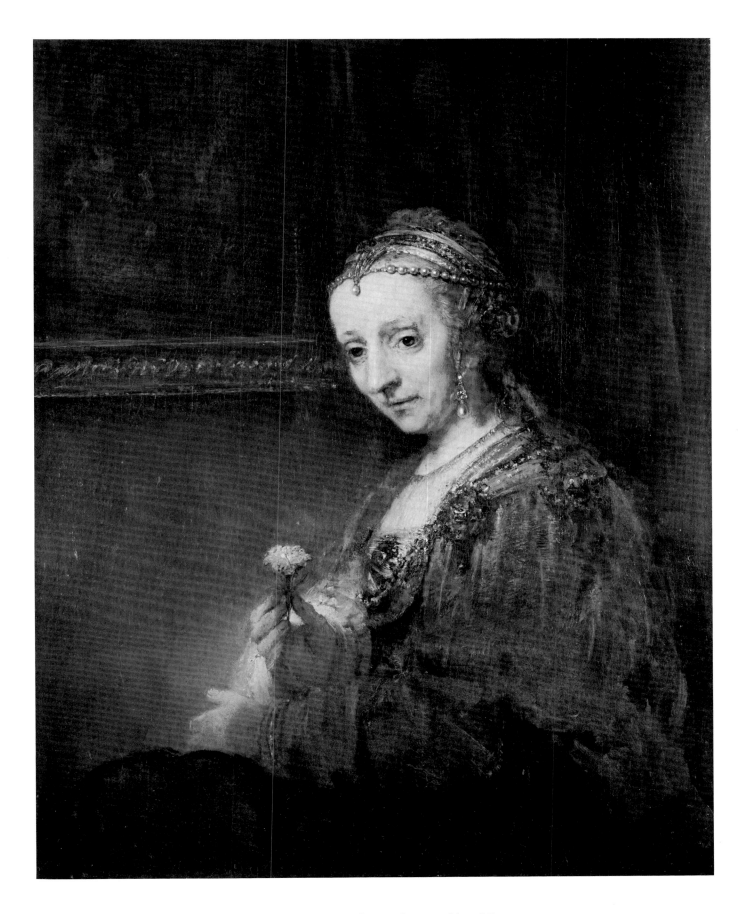

Plate 55. REMBRANDT HARMENSZ. VAN RIJN, *Lady with a Pink,* ca. 1663. Oil on canvas, 92.1 x 74.6 cm. (36¼ x 29⅜ in.). The Metropolitan Museum of Art, Bequest of Benjamin Altman, 1913, 14.40.622

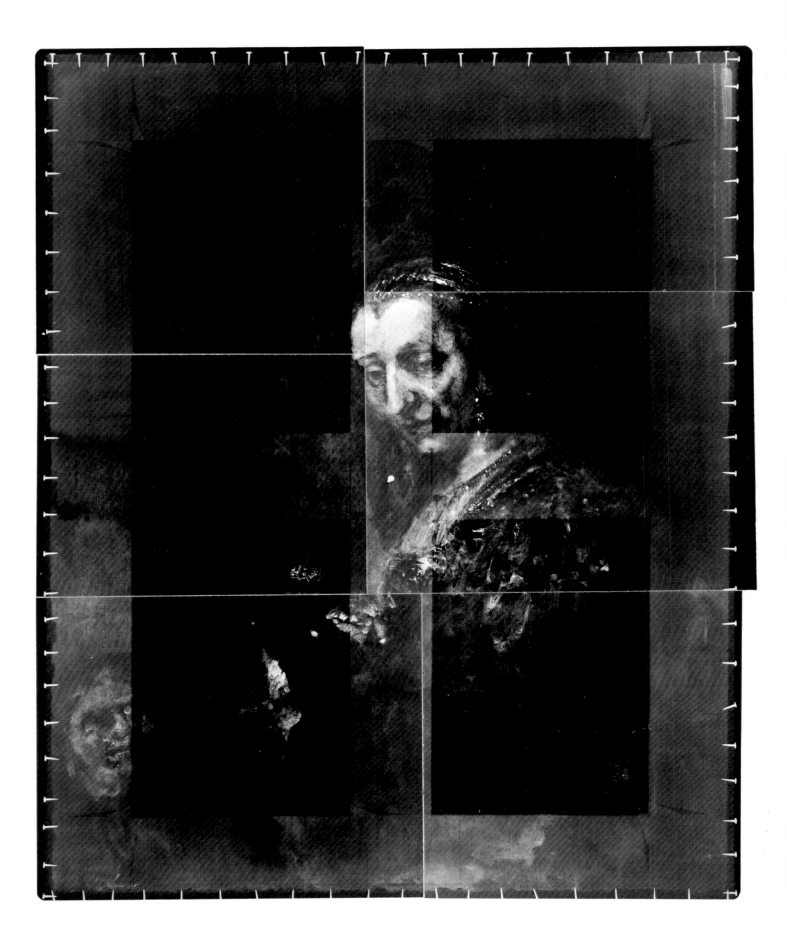

Plate 56. X-ray radiograph, *Lady with a Pink*

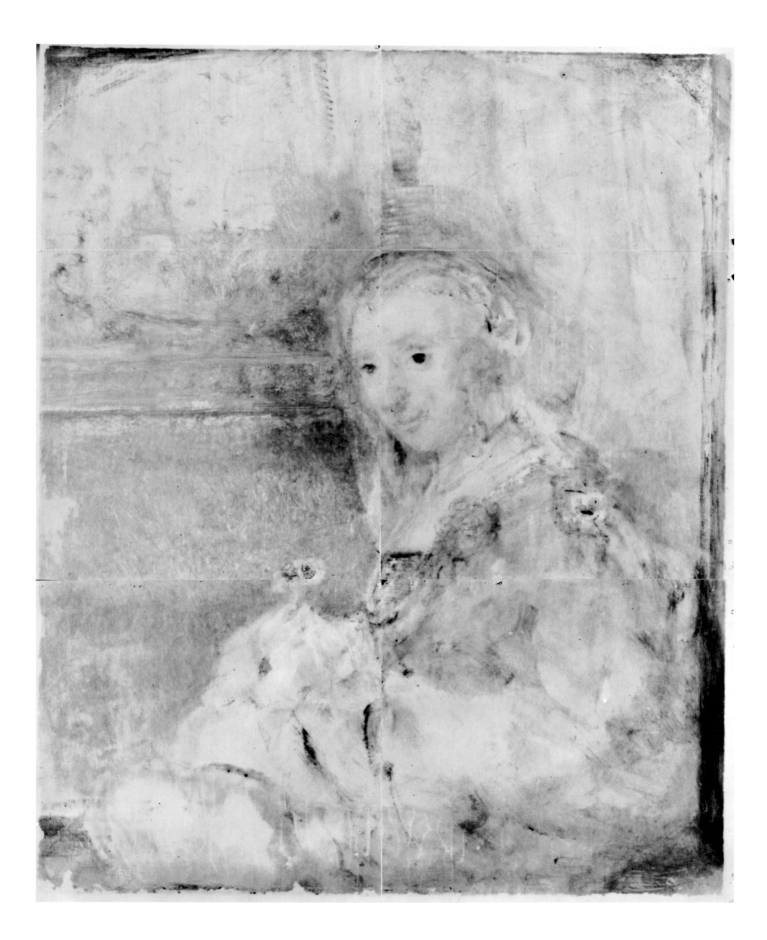

Plate 57. Eighth autoradiograph, *Lady with a Pink*

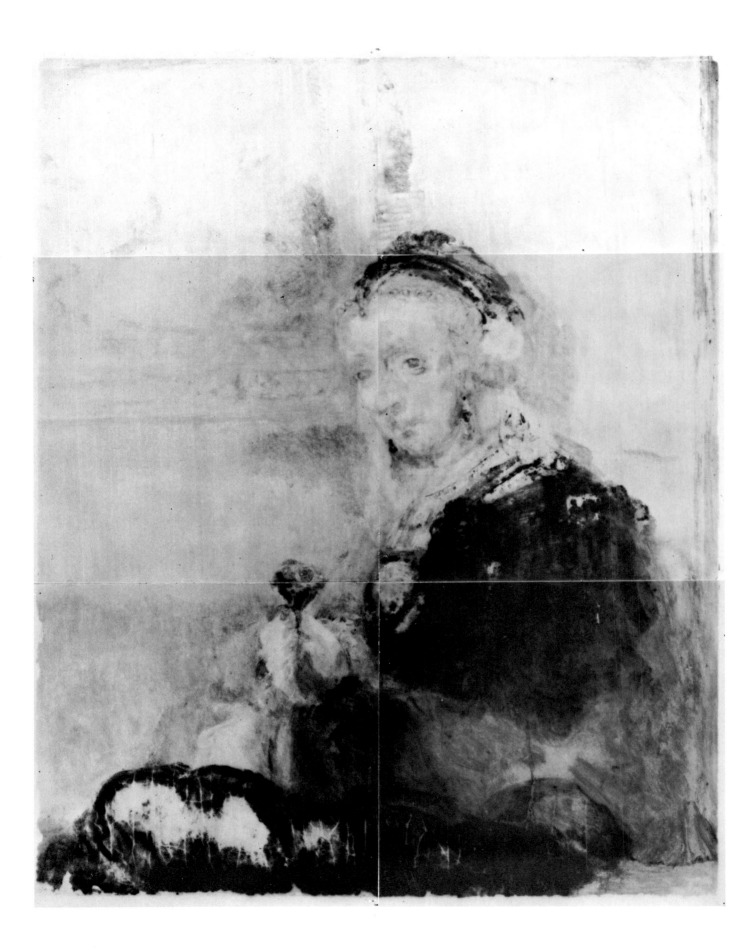

Plate 58. Sixth autoradiograph, *Lady with a Pink*

Portrait of a Young Man
(The Auctioneer)

Though it has long been considered an autograph work, some scholars have questioned the attribution of the painting in Plate 59 to Rembrandt (F. Schmidt-Degener, E. Haverkamp-Begemann).[61] Autoradiography is helpful in revealing more clearly some aspects of the technique of this work that are not entirely consistent with the Rembrandt paintings of the 1650s examined in this study.

The usual clear painted sketch visible in the autoradiographs of contemporary Rembrandt paintings such as *Flora* or the *Man with a Magnifying Glass* is lacking here. Strokes that appear sketchlike in Plate 61 are not found in the underlayers but on the surface of the painting. In addition, the torso is not well established in any of the autoradiographs, and the broad brushstrokes and palette-knife markings of the cloak appear as a technical feature (Plate 62) rather than as the convincing definition of form seen in the torso of *The Standard-Bearer* (Plate 38).

Of particular note is the absence of the characteristic buildup of brushwork for lighting effects in the background. Instead, spatial definition is attempted by an arrangement of summarily defined objects—the ancient bust, a curtain, and a column. Previously (Plate 61), a window at the upper left was also included, perhaps in the place of the column. Such a confusion of objects in the background is unusual for Rembrandt, who mastered the definition of color and light through well-integrated but varied brushwork.

A number of pentimenti are visible only in autoradiographs (compare Plates 60–62): the contours of the sitter's hat and the bust were changed slightly, and the hands and manuscript pages were moved further away from the body (Plate 61); the curtain was moved to the right (Plates 61, 62).

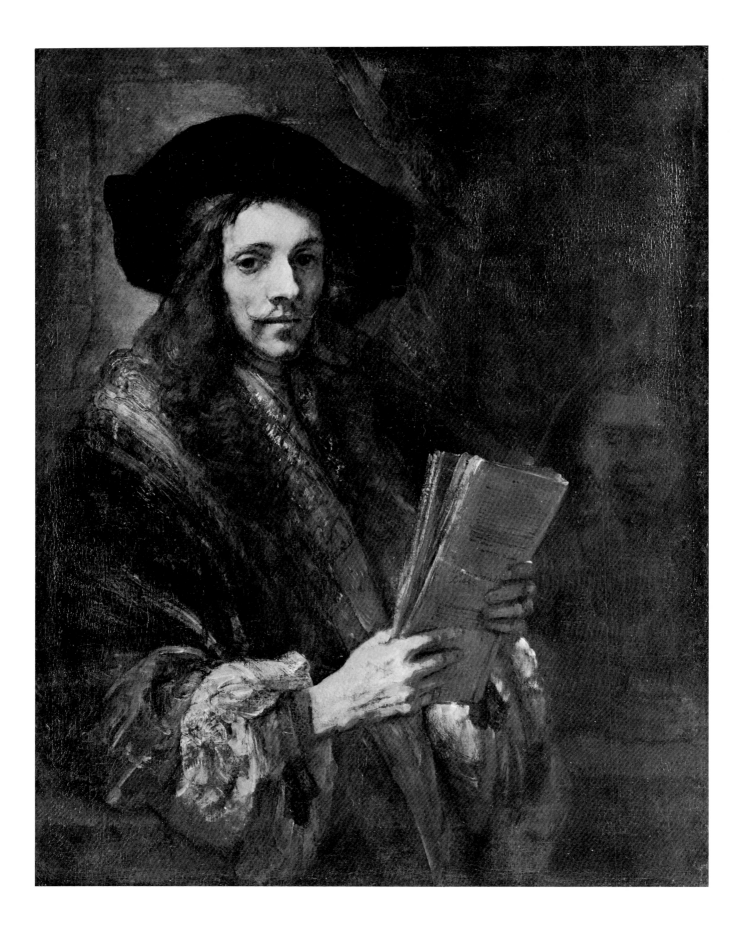

Plate 59. REMBRANDT HARMENSZ. VAN RIJN (?), *Portrait of a Young Man (The Auctioneer)*, signed and dated 1658. Oil on canvas, 108.6 x 86.4 cm. (42¾ x 34 in.). The Metropolitan Museum of Art, Bequest of Benjamin Altman, 1913, 14.40.624

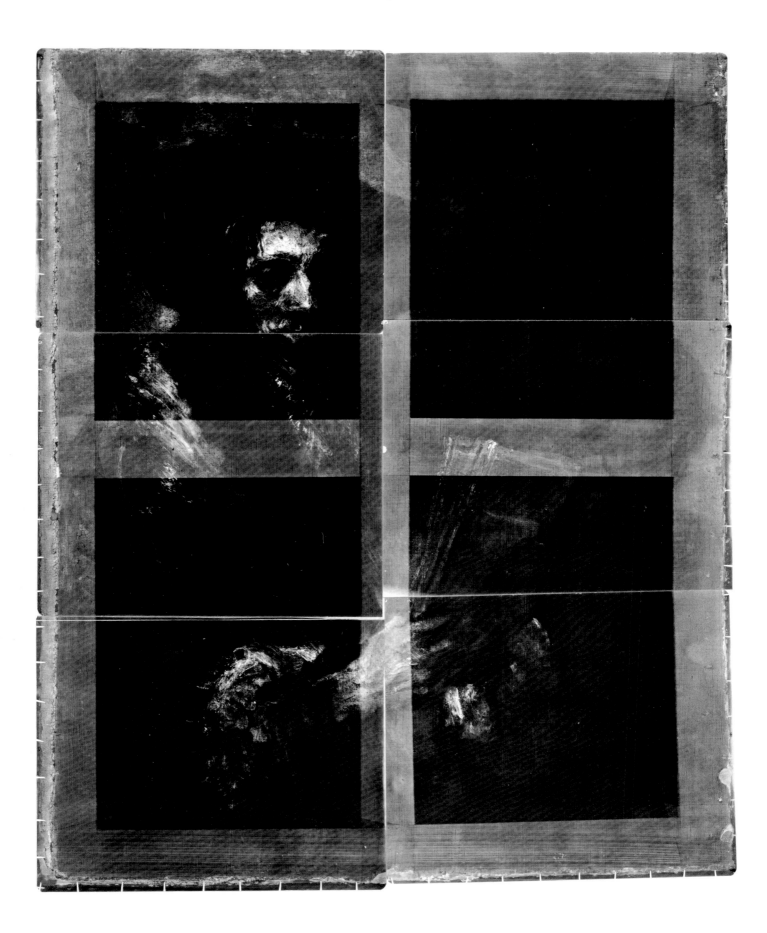

Plate 60. X-ray radiograph, *Portrait of a Young Man (The Auctioneer)*

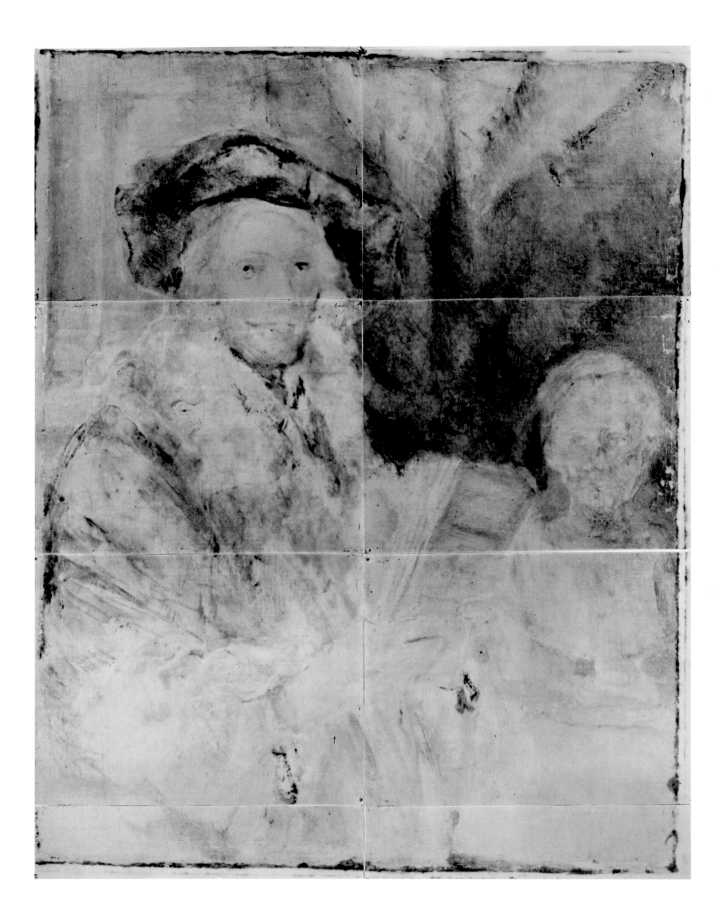

Plate 61. Eighth autoradiograph, *Portrait of a Young Man* (*The Auctioneer*)

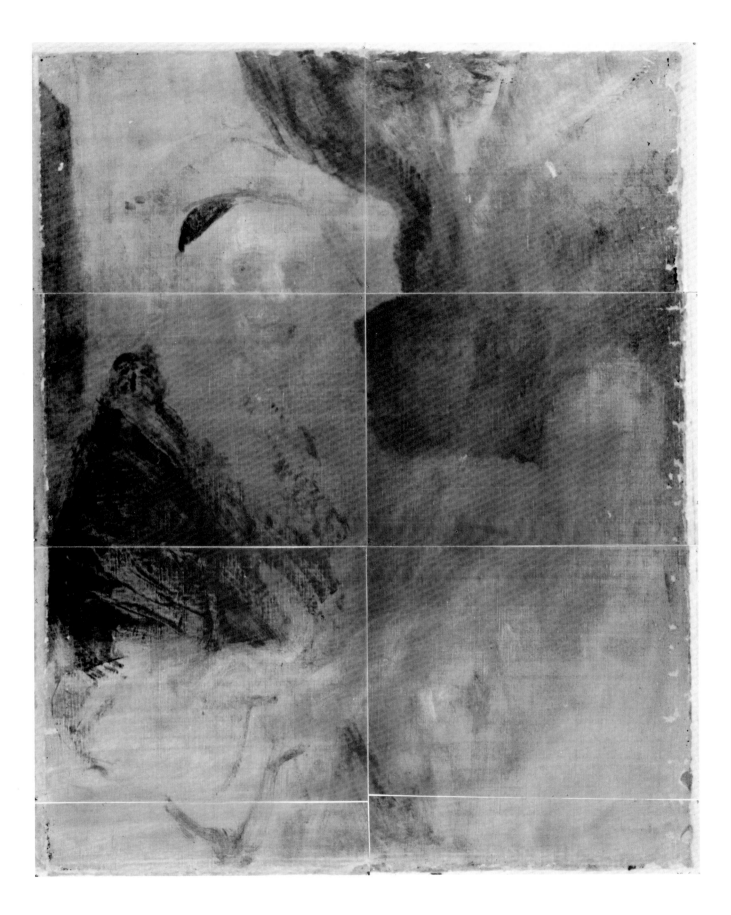

Plate 62. Sixth autoradiograph, *Portrait of a Young Man (The Auctioneer)*

In problems of attribution such as those posed by the *Christ with a Pilgrim's Staff* (Plate 63) the evidence gained through autoradiography is most helpful.[62] The X-ray radiograph (Plate 64) shows an uncharacteristic blending of lead-white strokes in the face and a less plastic handling than is evident in contemporary Rembrandt portraits (e.g., the *Man with a Magnifying Glass*). However, little more than this can be gained from the X-ray radiograph. The autoradiographs, on the other hand, give additional significant information. They indicate a style close to Rembrandt's but show certain variations that belie an attribution to the master himself.

Clearly the composition, the way the figure sits in space, and the handling of light in the background are all characteristic of Rembrandt's style of the 1660s. However, conspicuously absent is Rembrandt's method of accomplishing these effects. In this painting space defines the figure, rather than vice versa. The background area was reworked in an unusually large number of layers to approximate those effects that Rembrandt could achieve with an economy of means.[63] Unusual for Rembrandt, too, is the unaltered contour of the body and head and a lack of inner definition of the form (Plate 65). Nowhere in the autoradiographs is there a painted sketch visible for this figure. The vibrant, characteristic shorthand strokes of the faces of the *Man with a Magnifying Glass* and the *Self-Portrait* are absent here.

A conglomeration of nervous, mostly meaningless strokes creates a vibrato effect across the front of the figure (Plate 65). What might be read as a painterly approach, however, is spoiled by the apparent lack of meaning of individual or grouped strokes. Behind the figure is the only alteration in the painting. Here there is a slight shift of outline in the column at the right.

Though the composition and handling of light appear close to those found in Rembrandt's late works, there is a different approach to the achievement of these effects, which seems to indicate the work of a pupil.

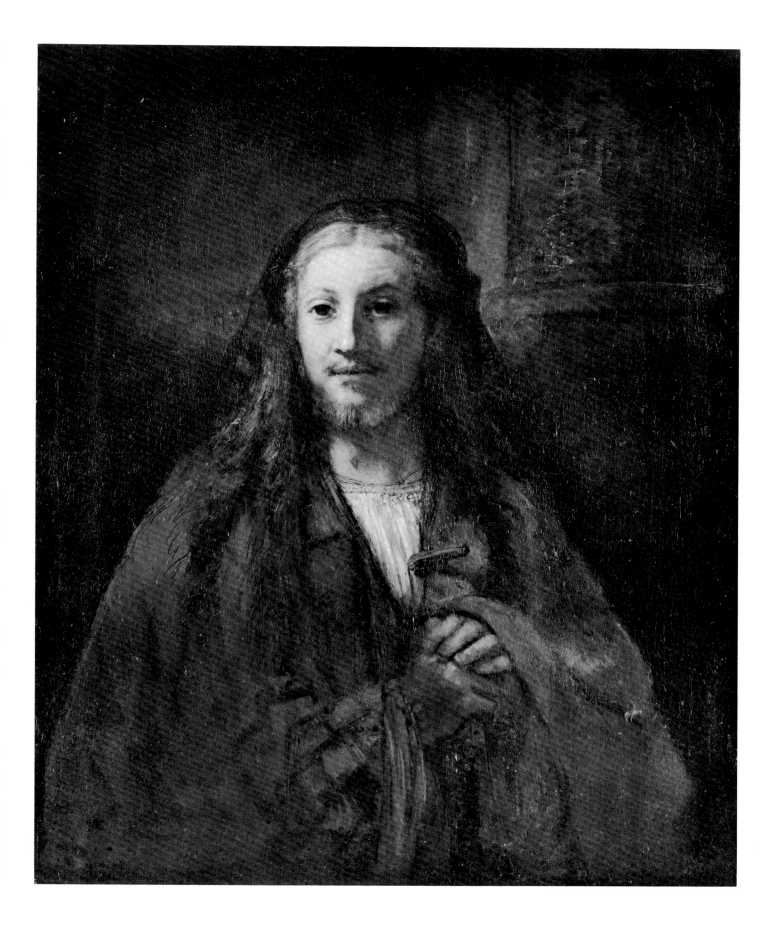

Plate 63. REMBRANDT HARMENSZ. VAN RIJN (?), *Christ with a Pilgrim's Staff,* signed and dated 1661. Oil on canvas, 95.3 x 82.6 cm. (37½ x 32½ in.). The Metropolitan Museum of Art, The Jules Bache Collection, 1949, 49.7.37

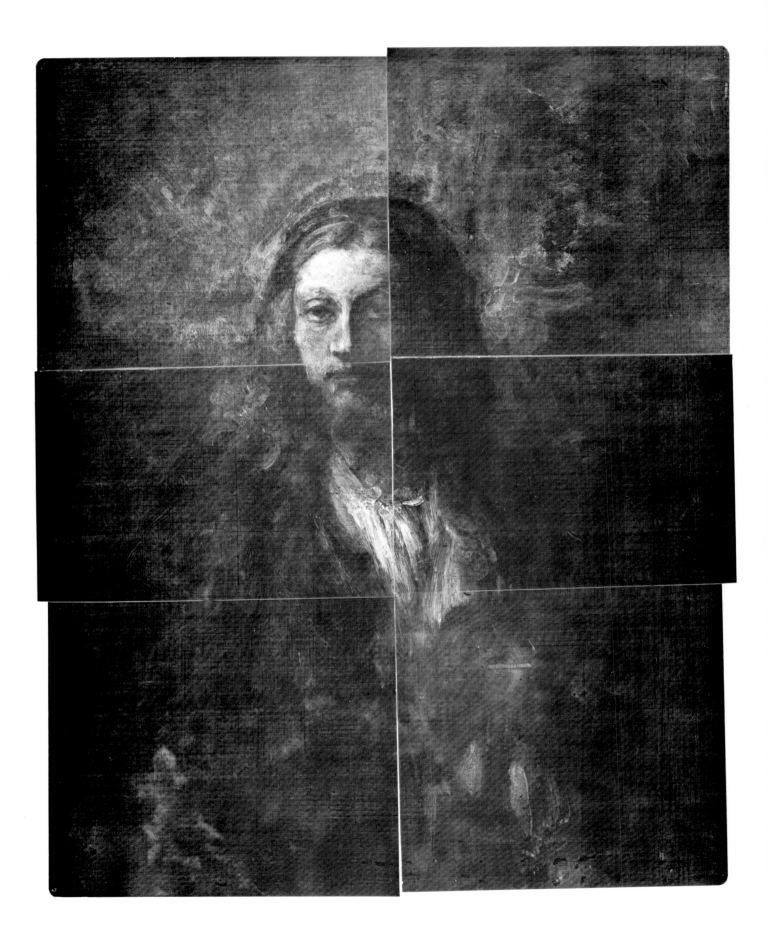

Plate 64. X-ray radiograph, *Christ with a Pilgrim's Staff*

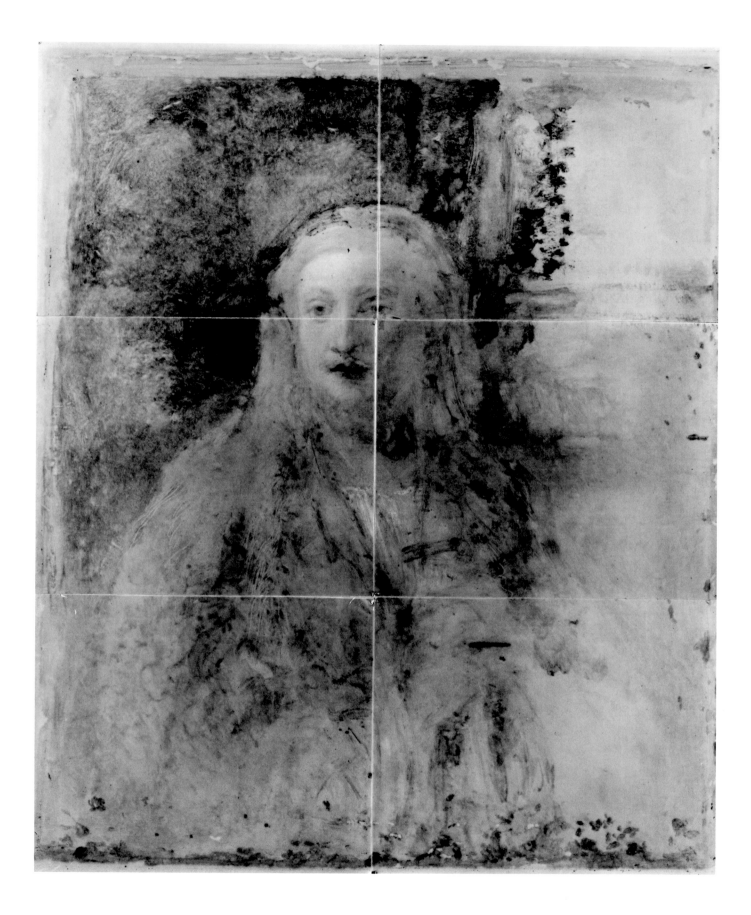

Plate 65. Sixth autoradiograph, *Christ with a Pilgrim's Staff*

In its use as a technique for the study of paintings, autoradiography is still in its infancy. Meaningful interpretation of these complex film images is hampered simply by a lack of familiarity with them. Even though this investigation constitutes a step closer to an accurate reading of the information available, certain features of the autoradiographs remain elusive, partly because of the limitations of the method. Though far exceeding the information accessible through X-ray radiography, what is presented in autoradiography nevertheless is incomplete. For example, as has been mentioned, the contribution of organic pigments to the makeup of a painting's structure and form is for the most part missing. Therefore, the autoradiographs are sometimes misleading in that they simplify what actually may be a more complex handling of paint. Those pigments that do appear are revealed in the film images regardless of the order in which they were applied, several different layers often being made visible simultaneously. Because of this, the examination of selected paint cross sections may be needed to establish the position of a specific paint application within the structure of the painting.

On the other hand, autoradiography is clearly an investigative method of remarkable potential. However effective, by comparison X-ray radiography now appears to have its limitations. By revealing information about the distribution of pigments other than lead white, autoradiography has increased substantially our understanding of an artist's creative process. Notable among the features now visible through this technique are the preliminary sketch and the specific manner in which an artist proceeded in working up the painting; more complete information about brushstroke and pentimenti is available. Though sometimes of significance for the iconography of a painting, these features invariably help with questions of attribution and later copies or imitations. Autoradiography is of particular value for the study of paintings in which colors have darkened, leaving portions of the composition illegible. In these cases, one may invariably expect results from autoradiography for individual paintings of various dates and origins. In general, autoradiography allows for a more accurate reading of a painting in every way. It is hoped that further use of this technique will help to elucidate many questions regarding the state of a painting as we see it now and the creative process by which it evolved.

1. From this point in the text autoradiography will be the term used when neutron activation autoradiography is meant.

2. Edward V. Sayre, "Revelation of Internal Structure of Paintings Through Neutron Activation Autoradiography," *1966 Proceedings First International Conference on Forensic Activation Analysis* (San Diego, Calif.), pp. 119–132; Heather N. Lechtman, "Neutron Activation Autoradiography of Oil Paintings" (M.A. diss., New York University, 1966); Edward V. Sayre and Heather N. Lechtman, "Neutron Activation Autoradiography of Oil Paintings," *Studies in Conservation* 13 (1968), pp. 161–185.

3. Maurice J. Cotter, Pieter Meyers, Lambertus van Zelst, and Edward V. Sayre, "Authentication of Paintings by Ralph A. Blakelock Through Neutron Activation Autoradiography," *Journal of Radioanalytical Chemistry* 15 (1973), pp. 265–282; Maurice J. Cotter, Pieter Meyers, Lambertus van Zelst, Charles Olin, and Edward V. Sayre, "A Study of the Material and Techniques Used by Some Nineteenth Century American Oil Painters by Means of Neutron Activation Autoradiography," *Applicazione dei methodi nucleari nel campo delle opere d'arte* (1976), pp. 161–203; Maurice J. Cotter and Kathleen K. Taylor, "Neutron Activation Analysis of Paintings," *The Physics Teacher* (May 1978), pp. 263–271; *The Seeing Eye*, exhibition, Heckscher Museum, Huntington, N.Y., Dec. 1977–Jan. 1978, research by Kathleen K. Taylor and Maurice J. Cotter, material assembled by Eva T. Gattling, Kate C. Lefferts, Pieter Meyers, and Edward V. Sayre; Maurice J. Cotter, "Neutron Activation Analysis of Paintings," *American Scientist* (Jan.–Feb. 1981), pp. 17–27.

4. Exceptions are organic painting materials containing additional elements that form radioactive isotopes upon neutron activation, such as bone black, which contains phospho-

rus; a dye or a mordant containing aluminum; or linseed oil if it contains sodium chloride.

5. For example, missing the characteristic buildup of paint layers seen in autoradiographs of seventeenth-century Dutch paintings are the Metropolitan Museum's *Head of Christ* (17.120.222), *Rembrandt's Son Titus* (14.40.608), and *Portrait of a Man with a Beard* (89.15.3).

6. John Rupert Martin and Gail Feigenbaum, *Van Dyck as Religious Artist* (Princeton, 1979), pp. 125–131; Charles Sterling, "Van Dyck's Paintings of St. Rosalie," *Burlington Magazine* 74 (1939), pp. 53–62; Maurice Vaes, "Le Séjour d'Antoine van Dyck en Italie," *Bulletin de l'Institut historique belge de Rome* 4 (1924), pp. 214–218.

7. Bayerische Staatsgemäldesammlungen, Munich, inv. no. 7449; Museo del Prado, Madrid, inv. no. 2556, ill. in Matías Díaz Padrón, *Escuela Flamenca* I (1977), p. 128, pl. 85.

8. Microscopic examination of paint cross sections shows that the brown sketch was composed of umber, lead white, an organic red pigment, and some ocher (Colorplate A).

9. Horst Vey, "Anton van Dyck's Ölskizzen," *Bulletin des Musées Royaux des Beaux-Arts* 5 (1956), p. 174.

10. Martin and Feigenbaum, *Van Dyck,* p. 28.

11. For example, the right leg and head of the angel at the lower right were subsequently covered by clouds.

12. Martin and Feigenbaum, *Van Dyck,* p. 126.

13. In other, perhaps later paintings (Wellington Museum, Apsley House, London; and Menil Foundation Collection, Houston), the crowning of Saint Rosalie is featured. For reproductions see Martin and Feigenbaum, *Van Dyck,* pp. 127, 129.

14. Van Dyck's comments on technique may be found in a manuscript in the Bodleian Library, Oxford. See Horst Vey, "Anton van Dyck über Maltechnik," *Bulletin van de Koninklijke Musea voor Schone Kunsten* 9 (1960), pp. 193–201.

15. Note that this blocking-out stage also makes no allowance for the upper left crowning angel. The wreath is evident here because of the presence of copper in the green leaves; it bears no relationship to a design phase.

16. In addition, Martha Wolff of the National Gallery, Washington, D.C., has observed that "some areas, such as the highlights on the scarf draped over the saint's arm or the leg of the angel at the upper right, are simplified or misunderstood in the Munich and Prado paintings" (personal communication, 1978).

17. Other closely related portraits are in the Bayerische Staatsgemäldesammlungen Alte Pinakothek, Munich (inv. no. 405); the State Hermitage Museum, Leningrad (inv. no. 548);

the Musée des Beaux-Arts, Strasbourg (these three ill. in G. Glück, *Van Dyck, Klassiker der Kunst* [Stuttgart, 1931], pp. 121, 122, 119); and in the Akademie der bildenden Künste, Vienna (ill. in *Akademie der bildenden Künste-Gemäldegalerie* [Vienna, 1972], cat. no. 170, ill. 20).

18. Cross-section analysis confirmed the use of these specific pigments.

19. Hubert von Sonnenburg, "Technical Comments," *Metropolitan Museum of Art Bulletin* 31, no. 4 (Summer 1973), n.p.; and Madlyn Millner Kahr, "Vermeer's Girl Asleep, A Moral Emblem," *Metropolitan Museum Journal* 6 (Fall 1972), pp. 118, 127.

20. The fifth autoradiograph (not ill. here) shows the abraded knobs and paint-filled valleys of the canvas weave, indicating a scraping action.

21. In addition to this information, cross-section analysis revealed that the man wears a red cloak or one underpainted with red.

22. Most notably S. Slive, " 'Een dronke slapende meyd aan een tafel' by Jan Vermeer," *Festschrift Ulrich Middeldorf* (Berlin, 1968), pp. 452–459; and Kahr, "Girl Asleep."

23. For information on grape symbolism, see E. de Jongh, "Grape Symbolism in Paintings of the 16th and 17th Centuries," *Simiolus, Netherlands Quarterly for the History of Art* 7, no. 4 (1974), pp. 166–190.

24. Kahr, "Girl Asleep," pp. 128–131.

25. Three of the paint cross sections taken show a distinct layer of medium only. This may indicate oiling out after a period of interruption in the working up of the painting.

26. See P. T. A. Swillens, *Johannes Vermeer, Painter of Delft 1632–1675* (New York, 1950), pp. 63–64.

27. It cannot be determined when the strengthening of selected letters in the signature may have occurred.

28. Concerning Rembrandt's technique, see bibliography, H. von Sonnenburg, "Maltechnische Gesichtspunkte zur Rembrandtforschung," *Maltechnik/Restauro* 82 (1976), pp. 21–24. Notable later studies include S. H. Levie et al., "The Night Watch Restored," and other articles in *Bulletin van het Rijksmuseum* 24, nos. 1, 2 (1976); H. Kühn, "Untersuchungen zu den Pigmenten und den Malgründen Rembrandts, durchgeführt an den Gemälden der Staatlichen Kunstsammlungen Kassel," *Maltechnik/Restauro* 82 (1976), pp. 25–32; H. Kühn, "Untersuchungen zu den Pigmenten und den Malgründen Rembrandts, durchgeführt an den Gemälden der Staatlichen Kunstsammlungen Dresden," *Maltechnik/Restauro* 83 (1977), pp. 223–233; K. Groen, "Schildertechnische aspecten van Rembrandts vroegste schilderijen," *Oud-Holland* 91, nos. 1, 2 (1977), pp. 66–74; E. van de Wetering, "De jonge Rembrandt aan het werk," *Oud-Holland* 91, nos. 1, 2 (1977), pp. 27–65;

A. B. de Vries et al., *Rembrandt in the Mauritshuis* (The Hague, 1978); H. von Sonnenburg, "Rembrandts 'Segen von Jacob,' " *Maltechnik/Restauro* 74 (1978), pp. 217–241. Further technical investigations of Rembrandt paintings will soon be published by the Rembrandt Research Project.

29. The ground of the Museum's 1660 *Self-Portrait* (14.40.618) appears to have been applied with a brush and that of the Museum's *Christ with a Pilgrim's Staff* (49.7.37) with a palette knife. Final conclusions about ground applications as observed in the autoradiographs cannot be reached without further examples and until additional study firmly establishes that the autoradiograph image originates from the front, not the back, of the canvas. The evidence of painting cross sections is so far inconclusive.

30. Max Doerner, *Malmaterial und seine Verwendung im Bilde* (Stuttgart, 1965), pp. 347–353.

31. Johannes Hell, "Beobachtungen über Rembrandts Malweise und Probleme der Konservierung," *Kunstchronik* 10 (1957), pp. 138–141.

32. E. van de Wetering, C. M. [Karin] Groen, and J. A. Mosk, "Summary Report on the Results of the Technical Examination of Rembrandt's Night Watch," *Bulletin van het Rijksmuseum* 24, nos. 1, 2 (1976), p. 75.

33. Ibid. This is not meant to imply that Rembrandt never made compositional sketches on paper, only that they are extremely rare now. See E. Haverkamp-Begemann, "Eine unbekannte Vorzeichnung zum 'Claudius Civilis,' " *Neue Beiträge zur Rembrandt-Forschung* (Berlin, 1973), pp. 31–40.

34. The unique advantage of autoradiography is that it locates exactly the underpainted sketch and thereby eliminates the guesswork in sample-taking for cross-section analysis of this stage of the painting procedure. In our study the underpainted sketch appeared most prominently in the late works of Rembrandt.

35. Van de Wetering, "Summary," p. 81. This working procedure is suggested by the artist and art theorist Gérard de Lairesse (1640–1711) in the *Groot Schilder-Boek* (Amsterdam, 1709), pp. 12–14.

36. Van de Wetering, "Summary," p. 84.

37. The observation that Rembrandt's male portraits appear to be of greater quality than their female counterparts has been made for several paintings, notably the 1633 pendants in the Herzog Anton Ulrich-Museum, Braunschweig (Br. 159, 338); and the 1635 pair of which one is in the National Gallery, London (Br. 202), and the other sold recently at Sotheby's (Oct. 22, 1980, Lot 12), New York (Br. 349). On these and other examples, see Horst Gerson's revisions of A. Bredius, *Rembrandt: The Complete Edition of the Paintings* (London, 1969), p. 576, nos. 331, 338; H. von Sonnenburg's

comments in "Technical Aspects: Scientific Examination," *Rembrandt After 300 Years: A Symposium,* Oct. 22–24, 1969 (Chicago, 1973), p. 91; these opinions are also supported by Haverkamp-Begemann (personal communication, 1979). Autoradiography may further contribute to an understanding of the apparent disparity in the quality of other portrait pairs.

38. Ibid.

39. No working stage, however, included a nude figure as stated by B. Haak, *Rembrandt: His Life, His Work, His Time* (New York, 1969), p. 101.

40. Microscopic examination of paint cross sections shows that the same green paint (composed of azurite, ocher, some brown and black particles) is used for these areas.

41. The confusion of brushstrokes to the lower right reveals other alterations of now-indeterminate form (Plate 30). The presence of a vermilion layer in this exact region cannot be explained satisfactorily.

42. Major references include G. J. Hoogewerff, "Rembrandt en een Italiaansche Maecenas," *Oud-Holland* 35 (1917), pp. 128–148; Corrado Ricci, *Rembrandt in Italia* (Milan, 1918); Jakob Rosenberg, "Rembrandt and Guercino," *The Art Quarterly* 7 (1944), pp. 129–134; Theodore Rousseau, "Aristotle Contemplating the Bust of Homer," *Metropolitan Museum of Art Bulletin* 20 (1962), pp. 149–156; Julius Held, *Rembrandt's Aristotle and Other Rembrandt Studies* (Princeton, 1969), pp. 3–44.

43. Microscopic examination of painting cross sections shows nine layers in the upper left arm. Quite possibly three of these are sketch layers of mostly bone-black material and a significant amount of glassy particles.

44. In a letter of May 28, 1980, Joyce Plesters of the National Gallery, London, considers the left hand: "In fact the layer structure as seen in the paint cross section is even more complicated than some other areas of the picture. There are alternating layers of opaque salmon-coloured paint and crimson-coloured glazes but the topmost layer happens to be opaque and not a final glaze!"

45. The decoration on the underside of the hat and on the costume below the apron is only visible in very strong light. During the cleaning of *Aristotle* both designs proved to be part of the original paint. Plesters's examination of paint cross sections below the apron showed the presence of a thick orange-yellow glaze over layers with a high content of blue glassy particles, possibly indicating a formerly green color now altered (letter, Oct. 9, 1980). Suggested is a very elaborate costume, the exact identification of which is currently being pursued.

46. In the 1673 inventory of Ruffo's collection the painting is described as No. 221, "Aristotele che tiene la mano sopra una statua, mezza figura al naturale," 8 x 6 *palmi* (V. Ruffo, "Galleria Ruffo nel secolo XVII in Messina,"

Bolletino d'Arte 10 [1916], p. 318). Previous calculations record the missing vertical dimension as ca. 53 cm. (or 20⅞ in.; J. Held, *Rembrandt's Aristotle,* p. 12; G. J. Hoogewerff, "Rembrandt en een Italiaansche Maecenas," p. 135); and ca. 70 cm. (or 27⁹/16 in., De Vries, *Rembrandt,* p. 172, and note 20). This use of the *palmi* measurements of Palermo and Messina respectively conflicts with the inventory description of the painting as a "mezza figura." By comparison with the seventeenth-century and current dimensions of other paintings that were in Ruffo's inventory or offered to him and that are now in the Metropolitan Museum (A. van Dyck, *Saint Rosalie Interceding for the Plague-stricken of Palermo,* 71.41; Mattia Preti, *Pilate Washing His Hands,* 1978.402), it is clear that the *palmus maior* (8¾ or 8½ in., 22.2 or 21.6 cm.) was used. The missing portions of the other paintings ordered by Ruffo to go with the *Aristotle* (especially *Homer,* Mauritshuis, The Hague) ought to be recalculated with this in mind.

47. Comparison of cross sections of samples taken within and outside of the scraped section confirmed the presence of an additional paint layer in the latter area.

48. In general, different paint applications appear in cross sections as distinct layers. In this instance, a paint cross section from the upper left corner of the painting showed a blending together of several layers (above the ground preparation). This indicates that one or more paint layers were applied over a wet layer.

49. Microscopic examination of paint cross sections located the sketch directly above the ground.

50. Cross-section analysis was used to determine the exact pigments used.

51. That is, except for the sketch line above the figure's right shoulder.

52. The following hat shapes have been identified in study of the X-ray radiograph and autoradiographs together: a painter's turban; a small beret; and a very full velvet hat with tassel (and extensions of this form to the lower right and left sides), the final version seen in the painting.

53. In our study we have not found a parallel for the lead-white strokes as they are used here.

54. In this case, the irregular sketch in bone black lies not directly on the ground, but midway in a succession of seven or more layers. As is also indicated by the cross sections of *Bellona,* perhaps a design in flesh tones was summarily indicated before the bone-black sketch was made.

55. The necklace motif may be found also in the portrait of Hendrickje Stoffels (Staatliche Museen Preussischer Kulturbesitz, Berlin-Dahlem), ill. in Gerson, ed., *Rembrandt,* p. 104.

56. The question of paintings left unfinished by Rembrandt has not been thoroughly studied. Autoradiography can add more evidence for the possible identification of such works.

57. The paint sample was taken to the right of the sitter's left shoulder in the first design for the figure (Plate 53; Colorplate I).

58. Cross-section analysis has identified this as an ocher-colored layer (of vermilion, glass splinters, some white and transparent dark brown pigments, and a little ocher) directly above the ground.

59. This layer, directly above the ground, is an orange-red mixture of lead white, vermilion, some dark brown, and an unidentified black pigment.

60. Jakob Rosenberg, *Rembrandt: Life and Work* (London, 1964), p. 348.

61. Schmidt-Degener (Museum's European Paintings Dept. files, April 1935) attributed the painting to Jan Lievens; Haverkamp-Begemann, personal communication, June 1979.

62. Haverkamp-Begemann was the first to voice doubt about the attribution of this painting to Rembrandt. Published opinions express wide acceptance of this work.

63. Examination of paint cross sections showed six ground layers and three upper layers. Late Rembrandt paintings examined in this study usually have two ground layers and two upper layers.

Photomicrographs of paint cross sections that have special significance for the autoradiography study

A.

From *Saint Rosalie Interceding for the Plague-stricken of Palermo*
Location: figure of angel with raised arms, right side of painting.

The dark brown layer over the thick ground is the initial sketch for the angel. This paint contains manganese-rich umber particles. Magn. 125×.

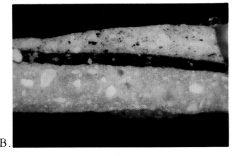

B.

From *Man in Oriental Costume (The Noble Slav)*
Location: lower left corner.

The dark layer over the second ground application is a manganese-rich umber paint and corresponds to the initial sketch of the design. Magn. 125×.

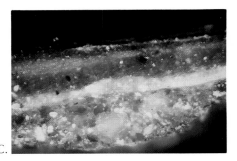

C.

From *A Girl Asleep*
Location: tablecloth.

The green paint layer of copper hydroxy carbonate (azurite) mixed with various other pigments corresponds to the overpainted design of grapes and grape leaves. Magn. 125×.

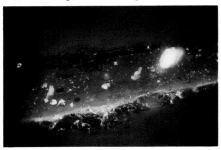

D.

From *Man with a Magnifying Glass*
Location: figure's right sleeve.

The coarse, transparent, and colorless particles seen below the red glaze and thin red ocher layers are glass particles containing arsenic and cobalt. Magn. 125×.

E.

From *Aristotle with a Bust of Homer*
Location: skirt of apron.

The main components of the dark paint are glass particles of varying color. They were found to contain cobalt and arsenic. Magn. 200×. (Photomicrograph by Joyce Plesters, National Gallery, London)

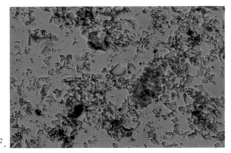

F.

From *Aristotle with a Bust of Homer*
Location: bottom right edge.

Photomicrograph with transmitted light of glass particles. Magn. 250×. (Photomicrograph by Joyce Plesters, National Gallery, London)

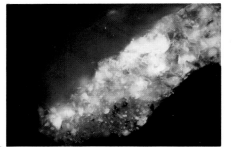

G.

From *Saint Rosalie Interceding for the Plague-stricken of Palermo*
Location: blue sky.

The lower layer shows the ground, which contains dark, manganese-rich umber particles. The upper layer consists of smalt, lead white, and probably ultramarine. Magn. 125×.

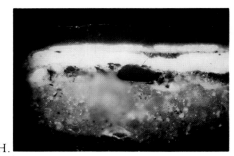

H.

From *Saint Rosalie Interceding for the Plague-stricken of Palermo*
Location: area of self-portrait, collar.

The ground layer contains dark, manganese-rich umber particles. The irregularly shaped black layer is the self-portrait sketch in bone black. This layer is covered by two layers of lead white divided by a thin layer of mostly colorless binding medium with locally black and red pigments. Magn. 125×.

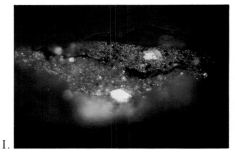

I.

From *Man with a Magnifying Glass*
Location: to right of the figure's left shoulder.

The uneven, thin black layer is composed of bone black and corresponds to the initial sketch. Magn. 125×.

2 *Pigments and Other Painting Materials*

Pieter Meyers
Maryan Wynn Ainsworth
Karin Groen

It is not practical to attempt to discuss here the technical information obtained from each painting examined. Instead, a summary is presented of the most significant results pertaining to painting materials observed in this study.

It was often possible to identify pigments solely on the basis of autoradiographic images and electron emission rate graphs. However, in some instances microscopic examinations of small pigment samples, microchemical tests, and/or X-ray powder diffraction analyses were necessary to achieve proper identifications. Furthermore, paint cross sections were prepared and examined through an optical microscope. A scanning electron-beam microscope (SEM)[1] was used to verify conclusions from the autoradiographic study and to determine the exact succession of paint applications. The electron microscope also contained an X-ray fluorescence spectrometer attachment that allowed semiquantitative elemental analysis of individual paint layers or pigment particles. Such paint cross-section analyses made it possible to decide which paint application among the multiple paint layers contributed to the images observed in the autoradiographs.

Autoradiographs generated during the first twenty-four hours after activation, the first four in the series of nine, show mostly the distribution of manganese in the ground. There is often little difference among the first four exposures. The images consist of a general darkening with the canvas structure clearly visible. Microscopic examinations of paint cross sections of some of the paintings provided the evidence that a manganese-containing dark earth pigment (umber or sienna) was mixed with either chalk, lead white, or ocher to produce a ground of the desired color (Colorplates G, H).

In some of the paintings studied the distribution of the manganese appears to be uneven. This may be due to the method of application of the ground; for example, in *Christ with a Pilgrim's Staff* and in Rembrandt's *Self-Portrait,* broad strokes are discernible in early autoradiographs. However, the possibility of the presence of manganese-containing materials either on the back of the paintings' canvas or on the relining canvas should be taken into account; their images may complicate a proper interpretation of the ground application.[2] For example, a close examination of the manganese distribution at the edges of autoradiographs of Van Dyck's *Saint Rosalie Interceding for the Plague-stricken of Palermo* seems to indicate that two ground layers are present, but a double ground for this painting could not be confirmed by cross-section analysis. Early autoradiographs from various paintings showed variations in density that seem to indicate higher manganese concentrations in the central portions of these paintings.[3] Whether or not this is the case is uncertain since this effect could be partly due to the inhomo-

geneous neutron flux during irradiation or to the presence of manganese-bearing materials used in relining.

Sketches made in umber or other manganese-bearing pigments could sometimes be distinguished superimposed on the image of the ground. They appear most prominently in autoradiographs of Van Dyck's *Saint Rosalie* (Colorplate A) and in some of Rembrandt's works produced in the 1630s (Colorplate B). Autoradiographs of the latter group of paintings showed that manganese-containing pigments were also used in background areas, especially around the contours of the figures (e.g., Plates 14, 21, 25).

Copper pigments, either green malachite or blue azurite, occur in most of the paintings studied. Autoradiographic images of copper are easily identifiable since they occur in the first autoradiograph, caused by a short-lived radioactive copper isotope. They have disappeared in the second autoradiograph and reappear again in the third, fourth, and fifth autoradiographs, caused by a longer-lived radioactive copper isotope. For example, the autoradiographic image of grapes and grape leaves in Vermeer's *Girl Asleep* is due to the use of azurite (Plate 10a; Colorplate C).

In some instances (e.g., *Man with a Magnifying Glass* and *Lady with a Pink*) parts of images in the fifth autoradiograph could be attributed to sodium. These images of the canvas were mostly a result of the presence of sodium in glue and other relining materials and as such did not contribute to the information on paint applications.

One of the most unexpected findings in this project is the frequent use of glass (or smalt) by Rembrandt in his later paintings. Its distribution in paintings can easily be traced since the glass particles contain arsenic. Because of its nuclear characteristics, arsenic, even in small quantities, is very effective in causing film blackening. The distribution of glass when present is clearly visible in the fifth, sixth, and seventh autoradiographs.

The glass resembles the blue pigment smalt in elemental composition. Both contain similar levels of potassium, arsenic, and cobalt, but they differ from each other in that the glass particles are much less intensely colored, are more transparent, and may vary in color from colorless to blue-green, gray, or brown (Colorplates D, E, F, G). Smalt was used extensively in Van Dyck's *Saint Rosalie* (Plate 4), where it was employed as a blue pigment freely filled in around the initial sketch. Its use for color in this painting differs greatly from the use of glass in Rembrandt's paintings, where glass appears mostly in specific dark-colored areas. This difference can be observed by comparing the sixth autoradiograph of *Saint Rosalie* (Plate 4) with those of Rembrandt's *The Standard-Bearer* (Plate 37) and *Man with a Magnifying Glass* (Plate 54), all showing predominantly the distribution of arsenic.

Glass particles may constitute up to ninety percent of the pigment materials present in individual paint applications in Rembrandt's works. It is well known that in the seventeenth century glass was added to oil paint in order to accelerate drying.[4] Its property as an extender may also have been prized. However, because of its concentrated use in painting applications and its appearance in specific areas of the painting's design, such as shoulders or sleeves, the drying capabilities of glass could hardly have been its only function. Rembrandt's ubiquitous use of glass was perhaps based on its desirable optical and mechanical properties. Since glass has also been identified by this research in seventeenth-century paintings by artists other than Rembrandt, its use is not characteristic of Rembrandt alone. Further study is needed to determine the extent to which this glassy material

differs from smalt and to establish more clearly its function in seventeenth-century Dutch oil paintings.

Part of the success of autoradiography applied to paintings can be attributed to its ability to reveal the initial sketch of the composition, when such a sketch is present. These sketches appear most clearly in the eighth autoradiograph. However, it was not evident from gamma-ray measurements which radioactive element was responsible for the image produced. When cross sections from relevant areas in the painting were analyzed, a black paint layer was observed (Colorplates H, I). The pigment in this layer was found to contain calcium and phosphorus and could be identified as bone black. It was then realized that radioactive phosphorus would produce autoradiographic images of bone-black paint applications.[5] Clear images of sketches made in bone black were obtained from many of Rembrandt's paintings, especially from his later works (e.g., Plates 29, 34, 41, 53, 57). The same pigment was also responsible for revealing the sketch of a Van Dyck self-portrait in the autoradiographic study of *Saint Rosalie* (Plate 5; Colorplate H).

Mercury is a major constituent of the red pigment vermilion. Much of the image seen in the ninth and last autoradiograph of each series can be attributed to mercury. Autoradiographic images frequently correspond to areas in a painting where vermilion is used in the upper layer of the painting, such as in flesh colors or in bright red areas of clothing. In Rembrandt's early portrait painting, for example, the vermilion used in the faces appears in the autoradiographs as distinct, almost cosmetic applications (Plates 13, 18, 22, 29). Vermilion was also used by Rembrandt, especially in his later works, as an admixture to other pigments.[6] Autoradiographic images of vermilion are not very intense, but they are often distinguished by their spotty or grainy appearance. This is due in part to the exceptionally low average energy of the beta particles emitted in the decay of radioactive mercury, which results in sharp autoradiographic images. The distinctive appearance of vermilion may also be due to its inhomogeneous distribution in the paint where the pigment particles are either grossly different in size or exist clustered together. R. J. Gettens and others mention certain conditions in which sizable aggregates of small individual vermilion particles can be formed.[7] In our study wide variation in particle size was observed only in a cross section of *Bellona,* where large lumps of vermilion could be seen in a matrix of small particles.

Images caused by radioactive cobalt are most clearly visible in the ninth autoradiographs. They were found to be identical to those of arsenic, though not nearly as intense. This similarity is not surprising since cobalt and arsenic have together been detected both in smalt and in glass.

Pigments such as ochers, lead white, lead-tin yellow, chalk, charcoal and lampblack, and red and yellow organic pigments do not produce significant blackening in any of the autoradiographs. A lead-white application can sometimes be seen in autoradiographs as a light image because of partial absorption of beta particles from an underlying layer. For example, in Plate 42, the manganese present in the ground layer is partially screened by lead white in the figure of Flora.

The major strength of the autoradiography technique is that it allows the observation of the structure of multiple paint applications beneath the surface. This study has not only enriched our knowledge of certain pigments and their use by Rembrandt and other seventeenth-century Dutch and Flemish artists, but, more importantly, it has shown that painting techniques can be reconstructed in great detail. Much new information on the working technique of Rembrandt has

been obtained; yet the number of paintings studied in this project was relatively small. Further autoradiographic studies applied to paintings by Rembrandt and related artists would unquestionably provide important additional information. Although facilities suitable for autoradiography are not readily available, we hope that such studies will take place in the near future.

1. Examinations with a scanning electron microscope were performed at Brookhaven National Laboratory, Instrumentation Department, using an AMR 1000 A Scanning Microscope and a Tracor-Northern 2000 X-ray Analyzer.

2. The images of the stretcher and cross-bars seen in the third autoradiograph of the *Lady with a Fan* (Plate 21) result from the presence of manganese on the back of the canvas.

3. See for example the third autoradiograph of *Man in Oriental Costume* (Plate 25).

4. For example, Mary P. Merrifield, *Original Treatises on the Arts of Painting,* Vol. 2 (New York, 1967), pp. 818–819; Ernst Berger, *Beiträge zur Entwickelungs-Geschichte der Maltechnik* 4 (Munich, 1901), pp. 80, 84.

5. Radioactive phosphorus, P-32, is one of the few isotopes that emits only beta particles; since it does not emit gamma rays, its presence cannot be confirmed by gamma-ray measurements and its electron emission rates cannot be calculated from the activation analysis results.

6. See also E. van de Wetering, C. M. [Karin] Groen, and J. A. Mosk, "Summary Report on the Results of the Technical Examination of Rembrandt's Night Watch," *Bulletin van het Rijksmuseum* 24, nos. 1, 2 (1976), pp. 79, 83.

7. Rutherford J. Gettens, Robert L. Feller, and W. T. Chase, "Vermilion and Cinnabar," *Studies in Conservation* 17 (1972), pp. 51, 52.

3

The Technical Procedures and the Effects of Radiation Exposure upon Paintings

Pieter Meyers
Maurice J. Cotter
Lambertus van Zelst
Edward V. Sayre

All paintings studied in this project are works in oil on canvas.[1] Each of the paintings was removed from its frame, and its condition was carefully examined before it was transported from The Metropolitan Museum of Art to Brookhaven National Laboratory, where all experimental work related to the neutron activation autoradiographic procedure was performed. A condition check was also performed upon the return of the painting to the Museum. The painting remained mounted on its stretcher during the entire process.

Neutron activation took place in the patient irradiation facility of the Brookhaven Medical Research Reactor. This facility is a small room into which a beam of reactor-generated neutrons can be directed through a vertical port measuring 12 by 12 inches (30.5×30.5 cm.). Before entering this room the neutron beam has passed through various layers of heavy water and bismuth metal to remove the more energetic fast and epithermal neutrons and gamma-ray radiation, leaving only a rapidly expanding cloud of very low-energy thermal neutrons.

The painting to be irradiated, wrapped in polyethylene to prevent contamination with radioactive dust, was placed and secured in a vertical position opposite and parallel to the entrance port at a distance of two feet. The painting was subsequently irradiated, receiving an average integrated neutron fluence of 5.4×10^{13} n/cm.[2] Specific information on the irradiation conditions is given in Table 2. All parts of the painting should ideally receive the same neutron dose. However, because of a diminution of neutron flux away from the center of the neutron beam, the edges of the painting may receive a factor 2 or 3 less neutron exposure than the center. This, however, will only have a small effect, usually negligible, on the quality of the autoradiographs.

Immediately after activation, the painting was removed from the irradiation facility and the radiation intensity from the painting measured. Its polyethylene cover was discarded and a one-mil-thick mylar sheet placed over the painting to protect its surface.

Autoradiographs are generated by placing photographic film for a predetermined time in close contact with the surface of the painting. The manner in which this is accomplished is shown schematically in Figure 12. Since the procedure involves the handling of unprotected film, it takes place in a darkroom lit only with safety lights.[3] The autoradiographs are generated on a vacuum table that contains a pad of foam rubber, ¾ inch thick, wrapped in polyethylene, of a size slightly larger than that of the painting. This provides a soft and safe cushion for the painting. Photographic film is placed on top of the pad.[4] Since the largest available size of this film is 14 by 17 inches, various pieces of it have

Table 2. Neutron Activation Data for Paintings Irradiated at the Patient Irradiation Port of the Brookhaven Medical Research Reactor

Irradiation position	Parallel to Neutron Entrance Port at 60-cm. distance
Ambient temperature	Approximately 20° C
Average neutron flux at irradiation position	1×10^{10} neutrons/sec./cm.2
Irradiation time	90 minutes
Fluence	5.4×10^{13} neutrons/cm.2
Gamma-ray dose rate	Approximately 200 millirads/sec.
Cadmium ratio*	37
Estimated total radiation dose received by each painting	1,740 rads
Activity of painting measured at end of neutron irradiation	2 roentgen/hours
Activity of painting measured 50 days after neutron irradiation	Less than 0.1 milliroentgen/hour

*Ratio of total neutrons to sum of epithermal and fast neutrons.

to be cut and joined together with pressure-sensitive tape to equal the size of the painting. The painting is placed face down on the film, and the area at the back between the stretcher and crossbars is filled with foam rubber to obtain an even surface. A sheet of surgical rubber is placed over this assembly. The surgical rubber is sealed at all edges on the table by aluminum bars and clamps. This allows a vacuum pump to withdraw air until the pressure between the surgical rubber and the tabletop is reduced by only one inch of mercury, thereby causing an even, gentle pressure on the painting and establishing good contact between the film and the painting's surface. After a predetermined exposure time, the painting is removed and the film is developed, fixed, and washed according to the manufacturer's specifications.

Figure 2 (Chapter 1) shows the schedule of autoradiography and gamma-ray measurements that take place during the fifty-day period following activation. After approximately fifty days nine autoradiographs have been produced. Each autoradiographic exposure shows the distribution of those painting materials that contain the most intensely radioactive elements at the time of exposure. Because of the differences in the decay times of the radioactive elements, different images

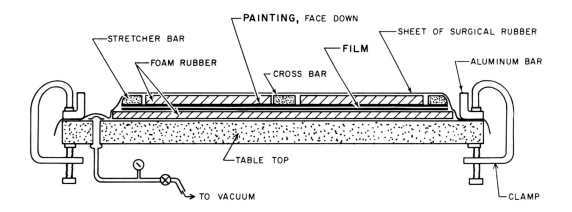

Figure 12. Schematic representation of the autoradiographic exposure procedure

are generally observed among the series of nine autoradiographs. This does not mean, however, that each of the nine autoradiographs is necessarily significantly different; consecutively produced autoradiographs sometimes show nearly identical images.

At three different times after activation, gamma-ray energy spectra of the painting are measured.[5] These measurements allow identification of most of the radioactive elements present in the painting. Only those elements with decay constants of less than thirty minutes or those that do not emit gamma rays remain undetected in this technique. From a comparison of the intensities of gamma rays in the gamma-ray energy spectra of the painting with those of a specially prepared uniform standard "painting" containing known amounts of the elements of interest, a quantitative estimate can be made of the relative abundance in the painting of each of those elements. Because of the inhomogeneous distribution of these elements in the painting and the necessary differences in the geometry of the painting relative to the detector from one measurement to another, these data cannot be considered as precisely accurate. However, calculated ratios of two elements should not be in error by more than a factor of 2. Other complications are caused by the canvas, stretcher, tacking nails, keys, and so forth, whose radioactive components cannot be differentiated by this technique from those in the

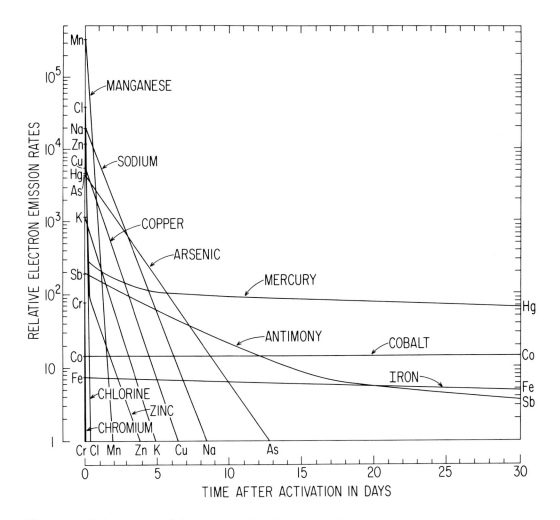

Figure 13. Relative rates of electron emission from activated elements within the painting *Saint Rosalie Interceding for the Plague-stricken of Palermo* as functions of the time after activation. The electron emission rate curve for phosphorus is not included because phosphorous activity cannot be measured from the gamma-ray spectrum measurements.

painting. For example, calculated iron values should certainly be expected to be high because of the contribution of iron from tacking nails. Nevertheless, these compositional data are helpful in that they provide approximate values of individual components in the painting.

The information of the gamma-ray energy measurements is also used to calculate the electron emission rates of each of the measured radioactive isotopes. It was determined by Sayre and Lechtman[6] that film darkening was almost exclusively caused by electron emission, i.e., beta particles emitted in radioactive decay. They furthermore concluded that the photographic density produced by this emission was proportional to the number of beta particles emitted per unit area of the painting during the exposure period. With the exception of the very low-energy cobalt-60 betas, all beta particles from all elements that were studied were roughly equally effective in producing film darkening. As a result, it appears that for each element its contribution to film darkening at any given time is roughly proportional to the electron emission rate for that element at that time. Electron emission rates for each element were calculated on the basis of gamma-ray measurements. For every painting a graph was constructed that showed for each element the calculated electron emission rates as a function of the time elapsed after activation. Figure 13 shows the electron emission rate graph for *Saint Rosalie*. These graphs were invaluable in determining which elements contributed to the film darkening in any specific autoradiograph and ultimately facilitated the identification of the pigment or painting material whose image appeared in that autoradiograph.

During the planning and execution of the present study, considerable attention was given to ensure the safety of the paintings. Handling and transport, as parts of the autoradiography procedure, were specifically designed to eliminate any risk of mechanical damage.

The effects on painting materials from exposure to radiation, particularly with regard to discoloration, increased brittleness, and decreased solubility of varnish and paint layers, have been studied in detail. Tests described below convincingly prove that the amount of radiation to which each painting was exposed in our work was several orders of magnitude below the level at which radiation damage, even to the most sensitive materials, can be detected. No changes in any of the irradiated paintings were ever observed, and no changes are expected to occur in the future as a result of their radiation history.

Sayre and Lechtman conducted experiments to investigate the effect of radiation doses up to 40,000 rads.[7] No changes in color could be detected. The brittleness and hardness of different paint layers and the solubility of the varnish in a test painting from 1920 or 1921 were measured before and after thermal neutron irradiations, which exposed the painting to a radiation dose of 6,000 rads. The test indicated that no significant changes had occurred.

On the basis of published information available at the time of their research, Sayre and Lechtman state that doses of the order of one million rads or more are usually required to produce significant changes in the structure and mechanical properties of organic materials and that in paint films it has been found that natural deterioration predominates over radiation effects unless the dose exceeds the 100,000-rad range. A search through the more recent literature on these subjects has not provided any information that would invalidate these conclusions.[8]

Nevertheless, there was a need to determine experimentally the levels of radiation doses required to cause measurable changes in various painting mate-

rials. For that purpose the following experiments were performed.[9] Test panels consisting of an unbleached linen support, with a liquitex acrylic polymer emulsion ground, were prepared. Each panel contained 2-by-2-inch painted applications of each of the following materials: damar, mastic, Winton Picture Varnish, Acryloid B-72, PVA-AYAA, PVA-emulsion, gelatin, linseed oil, walnut oil, raw umber, burnt umber, ivory black, vermilion, rose madder, raw sienna, green earth, copper resinate, smalt, indigo, natural ultramarine, orpiment, lead-tin yellow, red lead, and lead white. The pigment samples among these materials were suspended in a gum arabic medium before application.

Sections of the test squares of each material were exposed to very large radiation doses of 1 Mrad, 10, 40, and 100 Mrads (1 Mrad = 1,000,000 rads) of cobalt-60 gamma radiation at Brookhaven National Laboratory. Comparisons between irradiated and reference samples were made for color stability, solubility, and pencil hardness.[10] Exposures to doses of 1 Mrad and 10 Mrads did not cause a measurable effect on any of the materials, except for a scarcely noticeable change in solubility of the sample of Winton Picture Varnish that was exposed to the 10-Mrad dose. When exposed to a 40-Mrad dose, a slight decrease in solubility was detectable in damar, mastic, the PVA-AYAA mixture, and in Winton Picture Varnish, and small color changes were observed in damar, mastic, Winton Picture Varnish, PVA, gelatin, rose madder, copper resinate, natural ultramarine, and lead white. The same materials exhibited increased changes in solubility and color when exposed to a 100-Mrad dose. Also, the pigments green earth and lead-tin yellow became affected by this dose. However, even at this extremely high dose, Acryloid B-72, linseed oil, walnut oil, poppyseed oil, raw umber, burnt umber, vermilion, raw sienna, smalt, indigo, orpiment, and red lead remained unchanged. As will be demonstrated below, the radiation doses of 40 and 100 Mrads exceed the radiation doses received by paintings in our work by factors of more than 20,000 and 50,000 respectively.

Each painting studied by autoradiography has been subjected to the following types of radiation: thermal neutrons, fast neutrons, gamma radiation from external sources, and beta and gamma radiation from radioactive nuclides produced in the painting through interaction of thermal neutrons with painting materials.

1. Thermal neutrons

 The kinetic energy of thermal neutrons is too small to deposit energy directly in any material. They do cause nuclear reactions, but the number of individual atoms that interact with neutrons, only a few out of a million million, is so small that the effect of nuclear alteration through reaction per se is truly negligible.[11] The emission of radiation resulting from these reactions will be discussed under internal radiation.

2. Fast neutrons

 Fast neutrons can deposit energy in matter, mostly by inelastic collisions. On the basis of a comparison of the experimental conditions in our work and that of Sayre and Lechtman, the radiation dose received by each painting from fast neutrons is calculated as 300 rads.[12]

3. Gamma radiation from external sources

 This radiation has been found to be the major contributor to the total radiation dose that is received by the painting. The average dose of gamma radiation, experimentally determined at the painting irradiation position, is 1,100 rads.

4. Internal radiation

Sayre and Lechtman have made an estimate of the internal radiation dose absorbed by a painting as a result of thermal neutron activation.[13] The internal radiation is that emitted during and after activation by unstable products formed by neutrons interacting with nuclei in the painting. For their experimental conditions, the radiation dose, mostly from beta radiation, was calculated as 45 rads. Since the integrated thermal neutron flux in our experimental condition is higher by a factor of 7.5, the dose from internal radiation received by paintings in this project is calculated as 340 rads.

By adding the various contributions, the total radiation dose received by each painting in our work is estimated to be 1,740 rads.[14] It is evident from the information described above that the dose of 1,740 rads received by each painting is far below the level at which radiation damage, even to the most sensitive materials, has been detected. The dose received by paintings is about 1/600 of that at which measurable radiation effects on some of the most susceptible organic materials have been observed and less than 1/6,000 of the level at which our experiments showed a detectable effect on some of the painting materials tested.

1. Autoradiography is equally applicable to both canvas and panel paintings. General restrictions on travel of panel paintings prevented the inclusion of these works in our study.

2. The uniformity of the neutron exposure of individual paintings has been checked from time to time by exposing a grid made up of uniform, very pure iron wire to the same activation conditions as the painting and then measuring the uniformity of the activation of this grid.

3. The first and second autoradiographic exposures are exceptional in that they are produced in a normally lit room, using film wrapped in a light-sealed envelope. This procedure does not produce highest-quality autoradiographs, but practical considerations prevented the use of the darkroom for these autoradiographic exposures.

4. Kodak Medical No Screen, a double emulsion film, is used in eight of the nine autoradiographic exposures. For the fourth exposure, a slower and more finely grained single emulsion film, Kodak Professional Film, is employed.

5. Gamma-ray energy spectra are measured using a Ge-(Li-drifted) semiconductor detector coupled to a 4096 channel pulse height analyzer.

6. Edward V. Sayre and Heather N. Lechtman, "Neutron Activation Autoradiography of Oil Paintings," *Studies in Conservation* 13 (1968), pp. 166–170.

7. Ibid., pp. 177–180. Radiation doses are usually expressed in the unit "rad"; 1 rad is the amount of ionizing radiation that deposits an amount of energy equal to 100 ergs per gram material.

8. Malcolm Dole, ed., *The Radiation Chemistry of Macromolecules,* Vol. 2 (New York and London, 1973); Milton Burton and John L. Magee, eds., *Advances in Radiation Chemistry,* Vol. 4 (New York, London, Sydney, Toronto, 1974), pp. 307–388; H. H. G. Jellinek, ed., *Aspects of Degradation and Stabilization of Polymers* (Amsterdam, 1978), pp. 149–193.

9. The authors are most grateful to Mark Leonard for carrying out this testing program.

10. Color changes were observed by visual examination; solubility tests were performed with toluene, benzine, and various mixtures of these solvents using the method described by Sayre and Lechtman, "Neutron Activation," pp. 178–179; pencil hardness measurements were performed following the method of H. A. Gardner and G. G. Sward, *Paint Testing Manual* (Bethesda, 1962), p. 131.

11. Sayre and Lechtman, "Neutron Activation," p. 176.

12. Ibid., pp. 165, 176.

13. Ibid., pp. 182–183.

14. Special consideration should be given to the case of a painting with a glue lining. Glue, being a protein, contains about ten percent nitrogen. Aside from an egg-tempera medium, which might contain on the order of one percent nitrogen, glue is the only nitrogenous material one expects to find in or upon a painting. Nitrogen undergoes a very unusual reaction with thermal neutrons: it absorbs a neutron coupled with the emission of a proton, $N^{14}(n,p)C^{14}$, which results in a very localized radiation dose. The released protons travel only an extremely short distance, approximately 1/100th of a millimeter. Therefore, protons released in a glue layer would deposit their energy almost totally within that layer. We estimate the dose that would arise from this special reaction within a glue layer exposed to our activation conditions to be approximately 4,000 rads. An egg-tempera painting might receive from this reaction a radiation dose several hundred rads higher than a strictly oil medium painting.

List of Paintings Studied

Paintings by or Formerly Attributed to Rembrandt

THE METROPOLITAN MUSEUM OF ART

Man with a Steel Gorget, 14.40.601
Old Woman in an Armchair, 14.40.603
Rembrandt's Son Titus, 14.40.608
Old Woman Cutting Her Nails, 14.40.609
Pilate Washing His Hands, 14.40.610
Self-Portrait, 14.40.618
Man with a Magnifying Glass, 14.40.621
Lady with a Pink, 14.40.622
Portrait of a Young Man (The Auctioneer), 14.40.624
Head of Christ, 17.120.222
Man in Oriental Costume (The Noble Slav), 20.155.2
Hendrickje Stoffels, 26.101.9
Flora, 26.101.10
Portrait of a Man, 29.100.3
Portrait of a Lady, 29.100.4
Portrait of a Man with a Breastplate and Plumed Hat, 29.100.102
Portrait of a Lady, 29.100.103
The Sibyl, 30.95.268
Bellona, 32.100.23
Portrait of a Lady with a Fan, 43.125
The Standard-Bearer, 49.7.35
Christ with a Pilgrim's Staff, 49.7.37
Portrait of Rembrandt as a Young Man, 53.18
Saskia as Flora, 60.71.15
Aristotle with a Bust of Homer, 61.198
Man with a Beard, 89.15.3
Portrait of a Man, 91.26.7
Portrait of a Young Man with a Beret, 1975.373